LEGENDARY LOCALS

OF

SANTA FE

NEW MEXICO

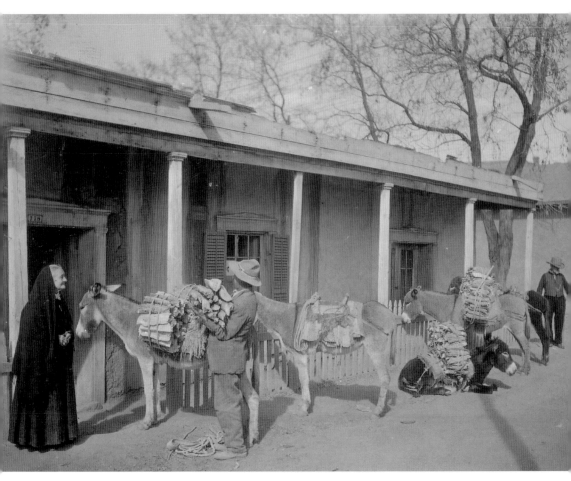

Santa Fe Wood Vendor
Through the early part of the 20th century, a comfortable winter in Santa Fe depended on prompt wood deliveries by vendors who traveled from the surrounding mountains with their burros. (Courtesy Palace of the Governors [NMHM/DCA], No.14478.)

Page 1: Santa Fe! City of the Holy Faith! End of the Santa Fe Trail!
This is a 1938 image by the Southwest Postcard Company, promoting Santa Fe. Tourism continues to be one of Santa Fe's main industries. (Courtesy Palace of the Governors [NMHM/DCA], No. 039352.)

Legendary Locals is an imprint of Arcadia Publishing
Charleston, South Carolina

Printed in the United States of America

Library of Congress Control Number: 2012944417

For all general information, please contact Arcadia Publishing:
Telephone 843-853-2070
Fax 843-853-0044
E-mail sales@arcadiapublishing.com
For customer service and orders:
Toll-Free 1-888-313-2665

Visit us on the Internet at www.arcadiapublishing.com

Dedication
This book is dedicated to Santa Fe's dearly departed and to those yet to arrive.

On the Cover: From left to right:
(TOP ROW) Fray Angelico Chavez, author and historian (Courtesy Fabian Chavez, page 29); Kimi Ginoza Green, community advocate (Courtesy Anne Staveley, page 115); Carl Tsosie, World War II veteran (Courtesy Connie Gaussoin Tsosie, page 101); Georgia O'Keeffe, artist (Courtesy John Candelario and the Palace of the Governors [NMHM/DCA], No.165660, page 40); Concepcion "Concha" Ortiz y Pino de Kleven, community leader (Courtesy Robert H. Martin, page 109).
(MIDDLE ROW) Ford Ruthling, artist (Courtesy Herb Lotz, page 47); Henry McKinley, cowboy (Courtesy Ana Pacheco, page 72); La Conquistadora, Santa Fe's Madonna (Courtesy Connie Hernandez, page 12); Molly Sturges, community activist (Courtesy Kate Russell, page 113); R. "Bear" Campbell, proprietor (Courtesy Linda Carfagno, page 92).
(BOTTOM ROW) Zozobra, marionette (Courtesy *Santa Fe New Mexican*, page 53); Genoveva Chavez, mariachi singer (Courtesy Herb Lotz, page 61); Jean Baptiste Lamy, archbishop (Courtesy Palace of the Governors [NMHM/DCA], No. 65116, page 16); Cholene Espinoza, Air Force pilot (Courtesy Cholene Espinoza, page 103); Adelina "Nina" Otero-Warren, community leader (Courtesy Palace of the Governors [NMHM/DCA], No. 89756, page 18).

CONTENTS

ACKNOWLEDGMENTS

The author would like to thank the following people and organizations:

Herb Lotz
Linda Carfagno
Daniel Kosharek
Mark Scharen
Palace of the Governors Photo Archives
Santa Fe New Mexican
First National Bank of Santa Fe
Adrian Bustamante
New Mexico State Records and Archives
Kimi Ginoza Green
Connie Tsosie Gausoin
Kate Russell
Jennifer Esperanza
Eliza Wells Smith
Daniel Driensky
Christus St. Vincent Hospital
Santa Fe Animal Shelter
Maria Benitez

Santa Fe Opera
Wheelwright Museum
Diana Bryer
Maria E. Naranjo
IAIA
Santa Fe Fiesta Council
Mike Ortiz
Steve Northup
Lydia Rivera
Anne Staveley
Rob Dean
John Sherman
Ben Swain
Robert Nott
David Coss
Robert Harcourt
George Donoho Bayless

INTRODUCTION

To know your future you must know your past.

—George Santayana

Santa Fe, the Ancient City, is my hometown. I'm the daughter of Jesus Pacheco and Natalie Ortiz. Both families settled in Santa Fe and northern New Mexico at the beginning of the 17th century. I'm proud of my family's legacy, and from 1994 until 2009, I published the quarterly journal La Herencia, which promoted the Hispanic heritage of New Mexico. When I was contacted by Arcadia Publishing to write this book, I was both honored and ready to take on the challenge of depicting the history of Santa Fe that started long before my ancestors' arrival and, today, includes a polyglot of humanity.

In 2010, Santa Fe celebrated its 400th anniversary. During the year-long celebration, the city paid homage to many important historical dates. The Native Americans have inhabited New Mexico for at least 11,000 years; during the 13th century, the Pueblo Indians began settlements along major rivers in proximity to Santa Fe. In 1598, the 1,600-mile trade route El Camino Real de Tierra Adentro was established, allowing trade and travelers access from Mexico City to Okhay Owingeh, formerly known as San Juan Pueblo. The Spanish explorer Juan de Oñate traveled along the Camino Real, establishing the first settlement at San Juan in 1598.

The year 1610 was given as the "official" founding of Santa Fe, although debate among historians continues. Santa Fe may have begun as early as 1601. The next important date is 1680, when the Indian leader Po'pay led the neighboring pueblos in war, pushing the Spanish settlers out of New Mexico during the Pueblo Revolt. The Spanish Crown was restored 12 years later, as Diego de Vargas regained the Spanish settlement of Santa Fe.

During the next century, conflict with nomadic Indians persisted in Santa Fe and surrounding areas. In 1806, the Louisiana Purchase brought the first American explorers. When Lt. Zebulon Pike and his men crossed the San Luis Valley in northern New Mexico, the Spanish authorities promptly arrested them and they were sent south to face a tribunal court in Chihuahua, Mexico. After four months, they were released and returned to US territory. In 1821, the Santa Fe Trail, which began in Franklin, Missouri, opened up trade with the United States.

This era through 1848 was known as the Mexican Period, when New Mexico was under the rule of Mexico. The east-west Santa Fe Trail provided the US Army with access to the area, enabling them to establish the American Occupation in 1846. In 1848, the Treaty of Guadalupe Hildago was signed, granting the US government land that today comprises the American Southwest and California. In 1850, New Mexico became a US territory. The following year, the Vatican appointed Jean-Baptiste Lamy bishop to Santa Fe. Lamy quickly went to work to establish the first archdiocese in the area and oversaw the building of the Romanesque St. Francis Cathedral, now known as the Basilica Cathedral of St. Francis of Assisi. Today, the cathedral continues to be the defining landmark in downtown Santa Fe.

During the Civil War, Union and Confederate soldiers fought at the Battle of Glorieta, 22 miles southeast of Santa Fe. During that skirmish, nearly 200 Confederate soldiers lost their lives. The railroad came to Santa Fe in 1878, providing a new and fast mode of transportation for people from the East. Businessmen, politicians, physicians, writers, artists, and other enterprising souls laid claim to the city and continue to shape the cultural landscape.

In 1912, New Mexico became the 48th state in the nation, with Santa Fe as its capital. Like the rest of the nation, Santa Fe was impacted by the Great Depression in 1929 and the Dust Bowl era of the 1930s. Government programs like the Works Progress Administration (WPA) and the Civilian Conservation

Corps (CCC) brought relief, not only to the citizens of Santa Fe, but to the thousands of people who passed through on their way to California in search of work. In 1943, during World War II, the atomic age got its start in Santa Fe when the Manhattan Project opened an office on Palace Avenue as a checkpoint for scientists and military personnel on their way up to "the Hill" at Los Alamos National Laboratory. After the war, Santa Fe's population doubled, to almost 50,000 people. Returning soldiers took advantage of the GI Bill and received education and technical training, and prosperity followed in many industries, from manufacturers to bankers starting businesses. New housing developments were built to accommodate the growing population. In 1956, the Santa Fe Opera was founded by John Crosby, placing the city on the classical music map. Aficionados trek to Santa Fe from around the world each summer to experience professional opera. Also in 1956, the Bacigalupa Studio of Gian Andrea was the first art gallery to open on Canyon Road, paving the way for many more. Santa Fe is one of the cities with the most art galleries per capita in the nation.

In the 1960s, during the Vietnam War, hippies moved to Santa Fe seeking an alternate way of life and, after the war, continued to shape the city. By the mid-1980s, Santa Fe's charm and ambiance went mainstream, and major media outlets began to market the town as the "Crown Jewel of the Southwest." Promoted for its temperate climate, breathtaking vistas, and as a cultural and cosmopolitan haven, the "City Different" drew people from all over.

Luxury housing developments began to sprout up, and the high cost of housing pushed many of the earlier residents out of town. Tensions between the "haves" and "have nots" began to disrupt some of the city's charm. With the advent of the personal computer, a new group of people descended on Santa Fe: those with the ability to "telecommute" to jobs in far-off places. By 2005, Santa Fe was designated this country's first United Nations Educational, Scientific and Cultural Organization Creative City.

If our forefathers were plopped down in Santa Fe today, they might feel as if they had landed on Mars. All of the changes that have taken place during the past 400 years would be completely foreign and incomprehensible to them. But, despite this transformation, they would recognize the same civic-minded, creative, intelligent, spiritual, hardworking people that they ventured with and encountered when they arrived. In the people of 21st-century Santa Fe, these brave adventurers would see themselves.

CHAPTER ONE

History

History is the version of past events that people have decided to agree on.

—Napoleon Bonaparte

Since the beginning of mankind, history has taught us that our evolution is both triumphant and tragic. For Santa Fe, the story began with the Native Americans, who were raped of their land and cultural traditions. In the tale of La Llorona (the wailing woman), her inconsolable spirit roams the Southwest, looking for her lost children (culture). The symbolic Cross of the Martyrs in Santa Fe, where 21 Spanish Franciscan priests and friars perished during the Pueblo Revolt of 1680, is yet another tragic part of our history. Two centuries later, Gen. Stephen Watts Kearny triumphantly established the first American settlement during the time that Doña Tules ran a successful gambling hall during the Mexican-American War. Bishop Jean Baptiste Lamy, the Sisters of Loretto, and the La Salle Christian Brothers came to Santa Fe in the 1800s, solidifying a foundation of faith and education. Adelina "Nina" Otero Warren advocated for women's suffrage during the early part of the 20th century. In 1926, Albina Lucero became the first female deputy sheriff in Santa Fe, and Amalia Sena Sanchez was the town's first Fiesta Queen in 1927.

Fast forward to a time still fresh in Santa Fe's collective psyche, the still-unsolved murder of Father Reynaldo Rivera in 1982. In 1996, and again in 1998, two brothers, Noah and Herman Rodriguez, became victims of hate crimes, murdered because of their sexuality. And, in the worst-case scenario for any parent, seven-year-old Robbie Romero disappeared in 2000, a crime that remains a mystery to this day.

But even before Santa Fe was subjected to the same types of crimes afflicting other parts of the country, in 1943, the Manhattan Project and the atomic bomb had its genesis in Santa Fe. Both triumphant and tragic, the development of the bomb changed the course of world history.

La Llorona

La Llorona, the wailing woman, is an important part of New Mexico folklore. The legend may have originated in 1520 with the Spanish conquest of Mexico. One story claims that La Malinche was the Indian mistress of the conquistador Hernan Cortes. Through the betrayal to her native people, she is banished from society and is destined to roam the riverbeds and streets of Santa Fe, northern New Mexico, and other parts of the Southwest in search of her lost children, which is metaphoric of her lost culture. (Courtesy Diana Bryer.)

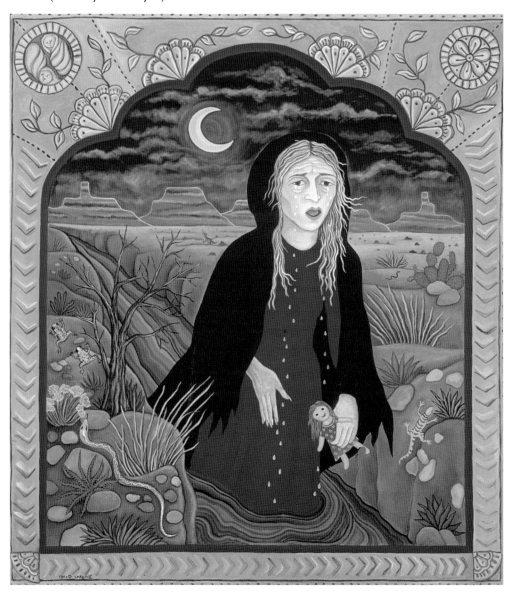

Juan de Oñate (1550–1626)

Oñate was the first Spanish explorer to reach New Mexico. His caravan of 130 soldiers and their families settled on the banks of the Rio Grande at Ohkay Owingeh, formerly San Juan Pueblo, 29 miles north of Santa Fe. Though history credits Oñate as a great explorer, he has also been criticized for his cruel treatment of Native Americans. This view is shared by many people today, with periodic demonstrations at historical sites that honor the conquistador. (Courtesy Palace of the Governors [NMHM/DCA], No. 000959.)

Pedro de Peralta (c. 1584–1666)

Peralta was appointed by Spanish viceroy Luis de Velasco II as the founding governor of Santa Fe. The busy thoroughfare Paseo de Peralta is named in his honor. The bronze sculpture of Pedro de Peralta by Dave McGary is located west of Federal Place in Santa Fe. (Courtesy Eiza Wells Smith.)

Po'pay (c. 1630–1688)

Po'pay was a Native Indian from Ohkay Owingeh (formerly San Juan Pueblo). He served the Tewa people as an Indian medicine man and religious leader. In light of the suffering of his people under Spanish rule, he masterminded the Indian Pueblo Revolt of 1680, successfully driving the Spaniards out of New Mexico for 12 years. His statue is one of two on display in the National Statuary Hall in Washington, DC. The other statue is of Sen. Dennis Chavez. (Courtesy *Santa Fe New Mexican.*)

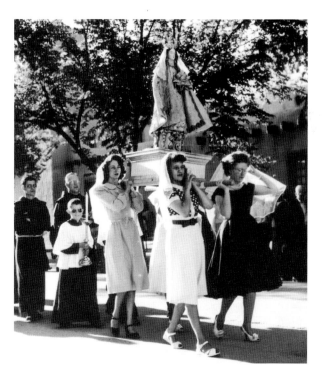

La Conquistadora

Santa Fe's revered Madonna arrived in 1625 from Mexico City, carried in the arms of Fray de Alonso de Benevides. From that moment on, La Conquistadora has represented Santa Fe's Spanish faith and legacy. The honoring of La Conquistadora is central to the annual Santa Fe Fiesta, the nation's oldest continuous community celebration. In the 1980s, she was given the added title "Our Lady of Peace" by Archbishop Robert F. Sanchez as a way to bring reconciliation to the Native American community. In 1973, to the shock of the community, La Conquistadora was stolen, the result of a teenage-prank. But the icon was quickly recovered. (Above, courtesy Robert H. Martin; below, courtesy Connie Hernandez.)

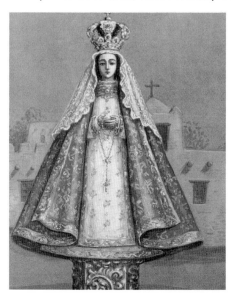

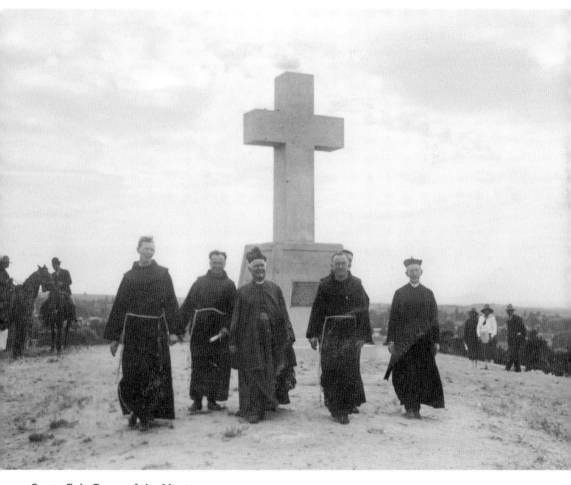

Santa Fe's Cross of the Martyrs
The Cross of the Martyrs in Santa Fe is a symbolic reminder of the 21 Franciscan priests and friars who lost their lives during the Pueblo Revolt of 1680. The closing ceremony of the Santa Fe Fiesta culminates in a candlelight procession to the cross. (Courtesy Palace of the Governors [NMHM/DCA], No. 052455.)

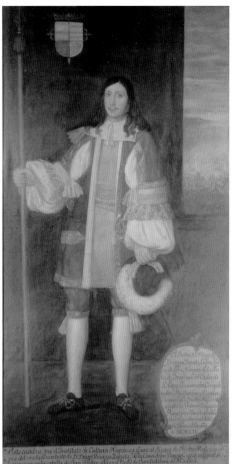

Diego de Vargas (1643–1704)

Diego de Vargas Zapata Lujan Ponce de Leon was baptized at San Luis Church in Madrid, Spain. He helped shape the future of the region when he reconquered New Mexico in 1692 following the Pueblo Revolt. He worked tirelessly with the Native American community in gaining their trust. De Vargas Middle School in Santa Fe is named for him. (Courtesy Palace of the Governors [NMHM/DC], No. 11409.)

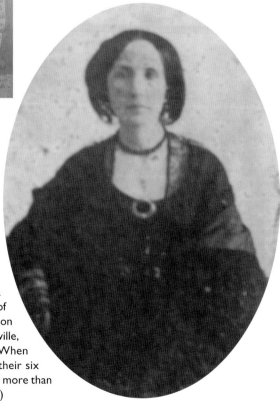

Mary Donoho (1808–1880)

Donoho was the first Anglo woman to travel along the Santa Fe Trail, from Old Franklin, Missouri, settling in Santa Fe in 1833. The energetic woman and her husband, William, operated a hotel where La Fonda is currently located. Two of their children, a girl born in 1835 and a son born in 1837, were documented as being the first Anglo Americans born in Santa Fe. In 1837, the young family fled during a time of political upheaval that resulted in the decapitation of Gov. Albino Perez. They moved to Clarksville, Texas, where they ran the Donoho Hotel. When Donoho's husband died in 1845, she raised their six children by herself and kept the hotel going for more than 30 years. (Courtesy George Donoho Bayless.)

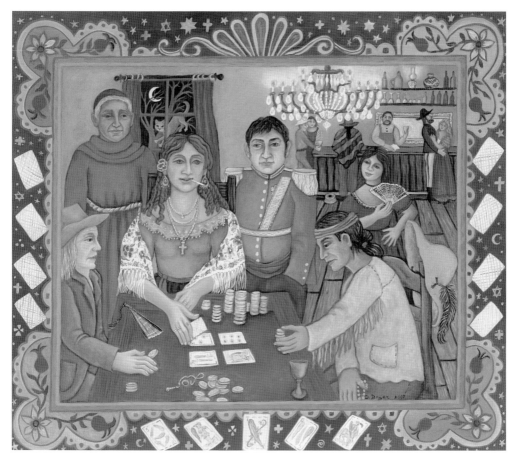

Doña Tules (c. 1800–1852)
Tules was an expert at the card game monte. During the mid-1840s, she operated a gaming hall that catered to Americans and Mexicans travelling along the Santa Fe Trail, which ended at the Santa Fe Plaza. Born Maria Gertrudes Barcelo, she was purported to be the mistress of Gov. Manuel Armijo, the last New Mexico governor under the rule of the Mexican government. As her business grew, she amassed a small fortune and became accepted into circles of high society. Having taken place at a time when few women had rights or visibility, the story of Doña Tules has caught the imagination of many, and she is one of the most written about women in New Mexico history. (Courtesy Diana Bryer.)

Archbishop Jean Baptiste Lamy (1814–1888)
Lamy was the first bishop and archbishop of the Diocese of Santa Fe. He was appointed to his new position by Pope Pius IX in 1850. Lamy arrived in Santa Fe a year later, and was met with resistance from the local clergy, but quickly took charge and began to transform Santa Fe. He ordered the construction of new churches and created new parishes and schools. By 1869, he started work on the Cathedral of St. Francis, now a basilica, which was completed in 1888. Lamy had the Romanesque church built similar in design to those of his native France, which was in complete contrast to the surrounding adobe structures. Throughout his time in Santa Fe, Lamy ruled with a strong hand amid controversy. Today, a statue of Lamy graces the front entrance to the basilica, and his body is interned below the church floor. (Courtesy Palace of the Governors [NMHM/DCA,] No. 65116.)

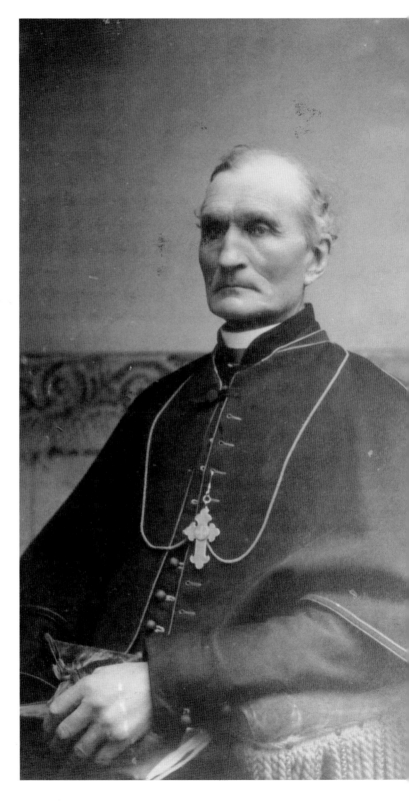

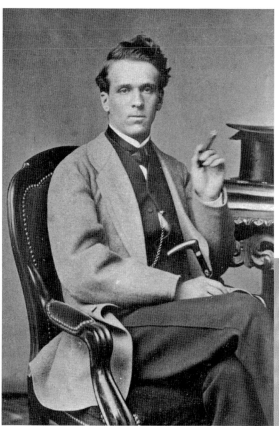

Adolf Bandelier (1840– 1914)
Bandelier lived at 352 East De Vargas Street in Santa Fe. In 1880, the Swiss-born anthropologist and writer explored ancient Native American dwellings 40 miles north of Santa Fe that were thought to have been inhabited for thousands of years. Bandelier National Monument is named in his honor. (Courtesy Palace of the Governors [NMHM/DCA], No. 9131.)

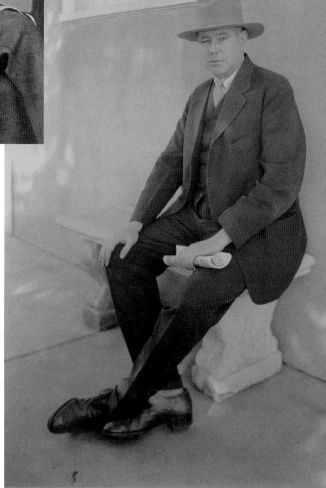

Sen. Bronson Cutting (1888–1935)
Cutting was the publisher of the *New Mexican* and the Spanish-language newspaper *El Nuevo Mexicano* in 1912, the year that New Mexico became a state. In 1927, he was appointed the Republican senator, a position he held until his death in a plane crash in 1935. (Courtesy T. Harmon Parkhurst and the Palace of the Governors [NMHM/DCA], No. 51501.)

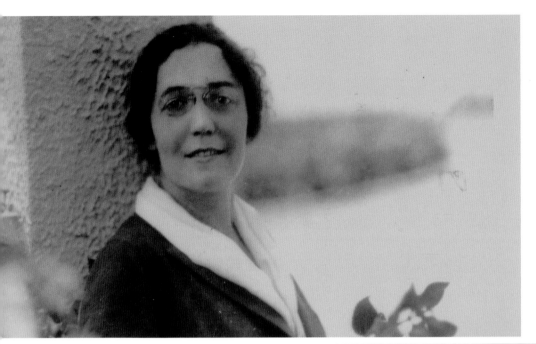

Adelina "Nina" Otero-Warren (1881–1965)

Otero-Warren led New Mexico's suffrage movement, helping to pass the 19th Amendment giving women the right to vote in 1920. She served in government and education positions throughout her life. She was the author of *Old Spain in Our Southwest*, which provided a view of Hispanic culture adapting to life under an American government. (Courtesy Palace of the Governors [NMHM/DCA], No. 89756.)

Albina Lucero (1879–1957)

In 1926, Sheriff Isais Alarid appointed Lucero as Santa Fe's first female deputy sheriff. Her job was to guard female prisoners at the local jail and to supervise local dances and community events. She was also a *partera* (midwife) and *curandera* (holistic healer). In the 1930s, Lucero received a certificate from the New Mexico Department of Health for assisting hundreds of women during childbirth. (Courtesy Lydia Rivera.)

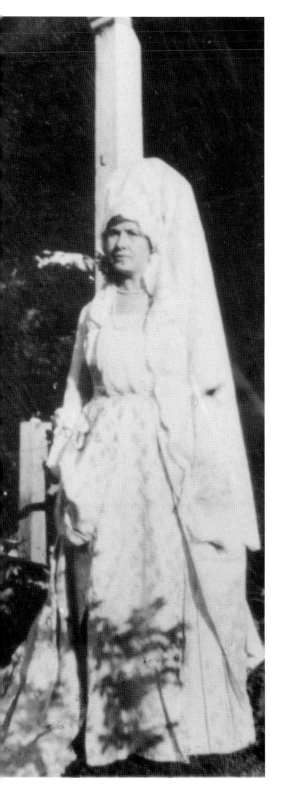

Amalia Sena Sanchez (1892–2003)
Sanchez was crowned Santa Fe's first fiesta queen in 1927. The Santa Fe Living Treasure died at the age of 109, having lived in three centuries. Throughout her life, she was a volunteer with the New Mexico Museum, the Red Cross, and other civic organizations. During that time, she volunteered at St. Catherine's Indian School, where she befriended Sister Katherine Drexel, the founder of the Order of the Blessed Sacrament, who was canonized a Roman Catholic saint in 2000. (Courtesy *Santa Fe New Mexican*.)

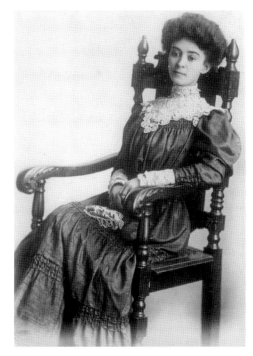

La Sociedad Folklorica
Las Sociedad Folklorica was founded by Cleofas Jaramillo in 1935 to preserve Spanish language, culture, and customs. For the past 78 years, the organization has played an integral role in preserving Spanish culture by sponsoring the annual *a merienda* (afternoon tea) and fashion show during the Santa Fe Fiesta. (Courtesy Palace of the Governors [NMHM/DCA], No. 9924.)

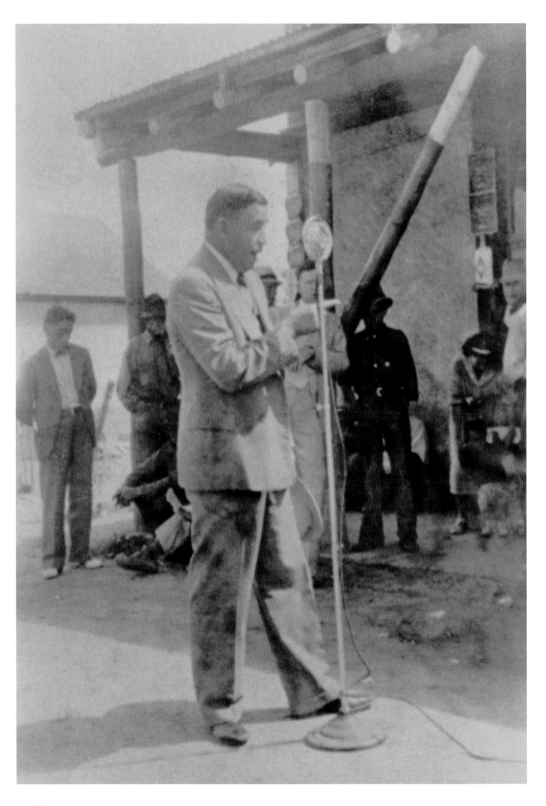

Sen. Dennis Chavez (1888–1962) (OPPOSITE PAGE)
In a bygone era, Chavez was touted by area newspapers as the greatest born New Mexican, living or dead. In reality, he was a political powerhouse and a tough, seasoned veteran of the state's turbulent political wars. In 1935, the New Mexico electorate sent him to the US Senate, where he filled the seat of Sen. Bronson Cutting after his death in a plane crash. During his 27 years in office, one of Chavez's many accomplishments was helping to pass legislation establishing the Pan American Highway. In the 1930s, he traveled throughout the villages and towns of New Mexico campaigning for Pres. Franklin D. Roosevelt, as pictured here. His statue is one of two from New Mexico on display in National Statuary Hall in Washington, DC. The other statue is of Po'pay, who led the 1680 Pueblo Revolt. (Courtesy of Ana Pacheco collection.)

Manhattan Project
Santa Fe was home to the men and women who created the first atomic bomb during World War II. Located on Trujillo Plaza at 109 East Palace Avenue, one block from the Santa Fe Plaza, this office was the first stop for the scientists and military personnel prior to heading up to "the Hill," in Los Alamos, 25 miles north of Santa Fe. Post office box 1663 was the official address for those working on the Manhattan Project between 1942 and 1945. (Courtesy Tyler Dingee and the Palace of the Governors [NMHM/DCA], No. 91931.)

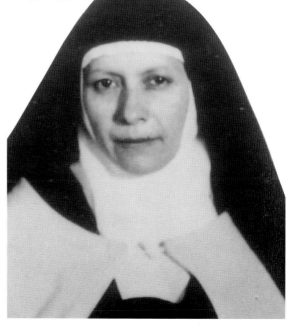

Carmelite Monastery
The Carmelite Monastery has had a presence in Santa Fe since 1945, when Mother Mary Teresa (shown here) and a handful of nuns, with the help of the community, built a monastery at its present location on Mount Carmel Road. The chapel was dedicated to the Sacred Heart of Jesus and St. Teresa. Today, the Carmelite nuns continue to be the heart and soul of Catholic Santa Fe and have many lay followers that are part of the Third Order of the Carmelites, which has over 30,000 members worldwide. (Courtesy Connie Hernandez.)

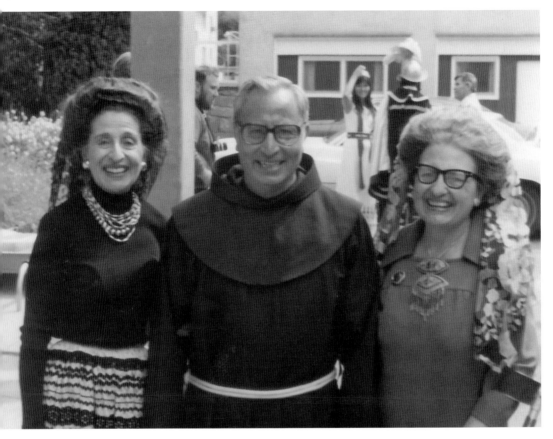

Fr. Reynaldo Rivera (1934–1982)
Rivera arrived in Santa Fe in 1975 to become a pastor at the Basilica Cathedral of St. Francis of Assisi. He served as chaplain of the Santa Fe Fiesta Council, where he added the Tewa language to aspects of the fiesta celebration in order to invite more Native Americans to share their culture. Around 8:45 on the evening of August 5, 1982, Father Rivera was summoned to give the last rites to a dying person. His body was found two days later one mile east of the Waldo Exit off Interstate 25. To date, Father Rivera's death continues to be one of Santa Fe's unsolved murder mysteries. He is pictured here with Concha Ortiz y Pino de Kleven (left) and her sister Mela Ortiz y Pino de Martin (right). Coincidently, Rivera, who was a Franciscan priest, was buried on the anniversary month of the 21 Franciscan friars who died during the 1680 Pueblo Revolt. The Cross of the Martyrs on Santa Fe's north side was erected in memory of those priests, and now, for many, Father Rivera is considered the 22nd priest murdered while doing God's work. (Courtesy of Ana Pacheco collection.)

Noah Rodríguez (1953–1996) and Herman Rodríguez (1959–1998)
The Rodríguez brothers grew up in a 200-year-old adobe house on Pacheco Street that was part of a Spanish land grant from King Philip V, awarded to the Rodríguez family in 1740. They were two of eight children born to Margaret Trujillo and Jose Rodriguez. In 1996, Noah (right) received the prestigious Michael Milken Family Foundation Outstanding Teacher Award. He was murdered that year. His younger brother, Herman (below), was a Santa Fe County board commissioner who also served on several foundation boards. He was murdered in 1998. Both brothers were victims of hate crimes. The shock of these two senseless murders reverberated throughout the community. In 2005, the City of Santa Fe named a park on the south side of town Los Hermanos Rodríguez Park in their honor. (Courtesy Margaret Rodríguez.)

Mayor Larry A. Delgado
and the City of Santa City Council
presents

The Dedication of

LOS HERMANOS RODRÍGUEZ PARK

Saturday, November 5, 2005
12 pm

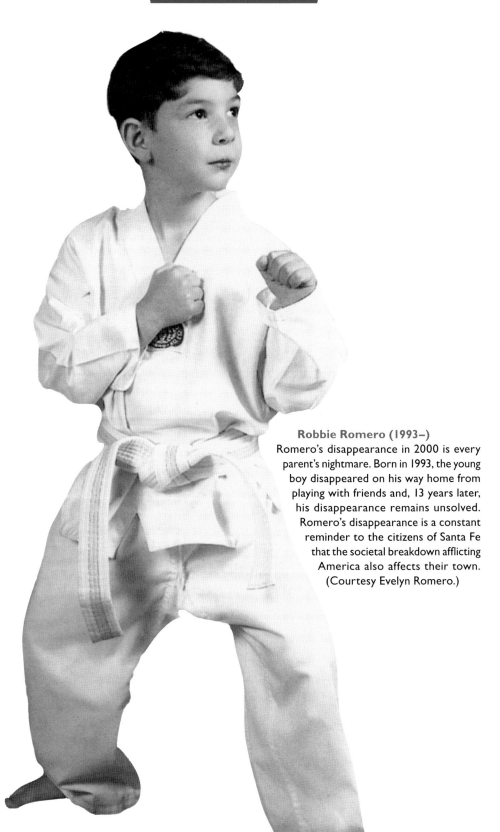

Robbie Romero (1993–)
Romero's disappearance in 2000 is every parent's nightmare. Born in 1993, the young boy disappeared on his way home from playing with friends and, 13 years later, his disappearance remains unsolved. Romero's disappearance is a constant reminder to the citizens of Santa Fe that the societal breakdown afflicting America also affects their town. (Courtesy Evelyn Romero.)

CHAPTER TWO

Literature

The difference between literature and journalism is that
journalism is unreadable and literature is unread.

—Oscar Wilde

The earliest record of the written word in New Mexico can be traced to Gaspar Perez de Villagra, who wrote the epic poem *La Historia de Nuevo Mexico* in 1598. His narrative chronicles the journey of Juan de Oñate and the first European founding of America. By the early 20th century, Santa Fe had an abundance of writers in both Spanish and English. Felipe M. Chacon, who wrote poetry and fiction, was the editor of several Spanish-language newspapers, including Santa Fe's *El Nuevo Mexicano*. Mary Austin coauthored the book *Taos Pueblo* with Ansel Adams. Oliver La Farge and Willa Cather both won Pulitzer Prizes for their writings on Santa Fe during their time here. The book *Origins of New Mexico*, by Fray Angelico Chavez, to this day remains the bible for area genealogists. For decades, Marc Simmons has provided generations of readers with the history of New Mexico through his historical column, "Trail Dust." Alice Khan Laddas, the author of the *New York Times* best-selling book *The G Spot and Other Discoveries about Human Sexuality*, lives in Santa Fe, as does Jacqueline Dunnington, the Marion scholar, who received two Apostolic Blessings from the Vatican for her books on Our Lady of Guadalupe. Joe S. Sando was the first Native American to document pueblo life in New Mexico. Evan S. Connell wrote the story collection *Mr. and Mrs. Bridge*, which was made into a movie of the same name starring Paul Newman and Joanne Woodward. Author and folklorist Nasario Garcia was given the Lifetime Achievement Award by the Historical Society of New Mexico in 2012 in recognition of his stellar contributions as an educator, community activist, and author of New Mexico history. Martha Egan, Pedro Ribera Ortega, and George Tate are some of the other writers that have lived in, written about, and made an impact in Santa Fe.

Gaspar Perez de Villagra (1555–1620)

Villagra was a captain in the Spanish military who traveled with the 1598 Juan de Oñate expedition to New Mexico. The soldier-scribe documented the first European foothold in North America in his epic poem, *La Historia de la Nueva Mexico*, in 1610. The ancient narrative chronicles the arduous journey of those who traveled with Oñate, including passage through a treacherous desert where even the horses suffered from all-consuming thirst. It also provided a succinct depiction of the cruelty thrashed upon the native people by the Spanish explorers. (Courtesy New Mexico State Records and Archives.)

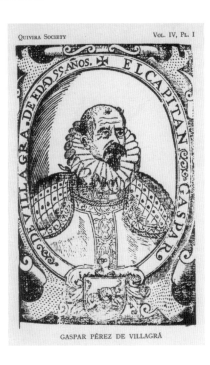

GASPAR PÉREZ DE VILLAGRÁ

Mary Austin (1868–1934)

Austin moved to Santa Fe in 1918 and befriended many writers and artists. During her career as a writer, she focused on the Mohave Desert and Native American life. In 1930, four years prior to her death, she coauthored the book *Taos Pueblo* with the photographer Ansel Adams. Mount Mary Austin in the Sierra Nevada is named in her honor. (Courtesy Palace of the Governors [NMHM/DCA], No.16754.)

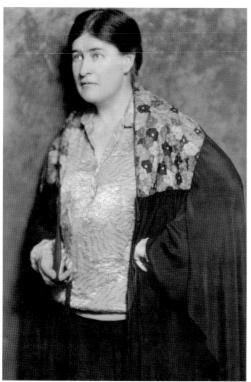

Willa Cather (1873–1947)

Cather wrote *Death Comes for the Archbishop* in Santa Fe in 1927. The quintessential book of that era was a thinly disguised fiction based on the life of Archbishop Jean Baptiste Lamy and the conflicts he encountered from the Spanish-Mexican clergy during New Mexico's Territorial Period. Today, the book is listed by the Modern Library as one of the best English-language novels of the 20th century. In 1973, the US Postal Service issued a stamp of Willa Cather. (Courtesy Palace of the Governors [NMHM/DCA], No.111734.)

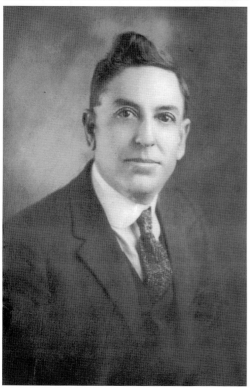

Felipe M. Chacon (1873–1949)

As a young man, Chacon was mentored by the well-respected Santa Fe historian and journalist Benjamin M. Read. Chacon went on to be the editor of several Spanish-language newspapers in New Mexico from 1911 through the 1930s, including Santa Fe's *El Nuevo Mexicano*. He was also the author of *El Cantor Nuevomexicano: Poesia y Prosa*. Published in 1924, the book of short stories and poetry was one of the few Spanish-language books of its kind during that era in New Mexico. (Courtesy Yolanda Rivera.)

Oliver La Farge (1901–1963) La Farge (center) was awarded a Pulitzer Prize in 1929 for his book *Laughing Boy*. A descendant of Benjamin Franklin, he spent many years in Santa Fe, where he championed the culture of Native Americans. As works of anthropology, his books offer accurate representations of Native American life during the 20th century. (Courtesy Mularky and Palace of the Governors [NMHM/DCA], No. 134801.)

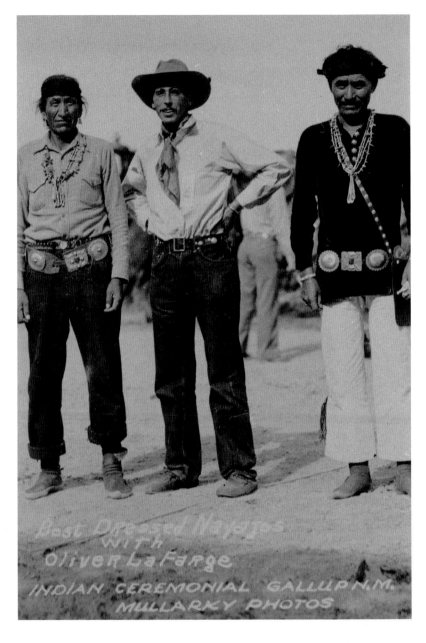

Fray Angélico Chávez (1910–1996) (OPPOSITE PAGE) Chavez, a member of one of Santa Fe's founding families, is considered the preeminent Hispanic historian of New Mexico. The Catholic priest was also an artist and the author of several books, including *Origins of New Mexico Families*, New Mexico's bible for genealogists researching their Spanish roots. The Fray Angelico Chavez Library at the Palace of the Governors is named in his honor. (Courtesy Fabian Chavez.)

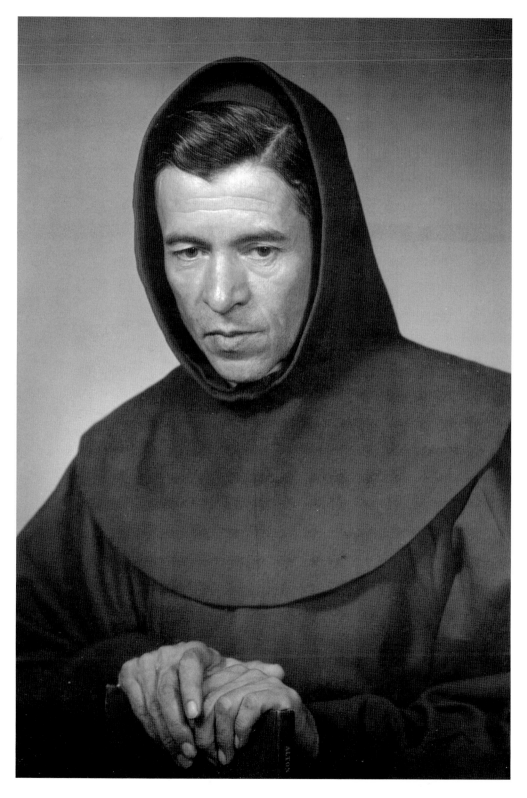

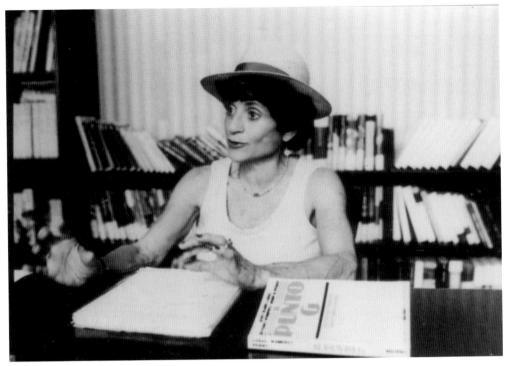

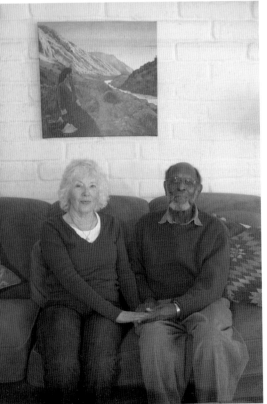

Alice Khan Ladas (1921–)
Ladas is the coauthor of the *New York Times* best-selling book *The G Spot and Other Discoveries about Human Sexuality*. The book has been translated into numerous languages and continues to have worldwide distribution. In 1994, Ladas moved to Santa Fe as part of the first wave of settlers in the multigenerational complex The Commons on the Alameda. Ladas has a private practice as a body psychotherapist and is a member of the Senior Olympics. She is shown here in 1973 in Italy promoting *The G Spot*. (Courtesy Alice Khan Ladas.)

George Tate (1925–)
Tate is the son of Godfrey L. Tate and Carrie E. Johnson, both children of slaves. Throughout his academic career, Tate has worked to improve race relations in this country. He received his PhD in pastoral counseling in 1975 from Iliff School of Theology in Denver. The retired professor is the author of several books and numerous articles, ranging in topics from religion to leadership. He moved to Santa Fe in 1998 with Ann Rader-Tate, and they are one of the growing number of interracial couples living in the area. (Courtesy Ana Pacheco.)

Joe S. Sando (1923–2011)
Sando arrived in Santa Fe at the age of 13 to attend the Santa Fe Indian School. He did not speak a word of English, but he could sing all of his Native American songs from the Jemez Pueblo in Spanish. Sando was the first Native American in New Mexico to document the culture of the Pueblo Indians through his many books, which have become invaluable documentation for historians. (Courtesy Joe S. Sando.)

Evan S. Connell (1925–2013)
In 2010, Connell received the Los Angeles Times Robert Kirsch Award and was also nominated for the Man Booker International book award in 2009. His books *Mrs. Bridge*, published in 1958, and *Mr. Bridge*, published in 1969, were made into a movie in 1990 starring Paul Newman and Joanne Woodward. Connell moved to Santa Fe in 1988. (Courtesy Linda Carfagno.)

Jacqueline Orsini Dunnington (1929–)
Dunnington is the author of three books and countless articles on Our Lady of Guadalupe. The Marion scholar moved to Santa Fe in 1982, because she wanted to live in a place that had an open spiritual tradition. In 1992, and again in 1997, the Vatican awarded Dunnington two Apostolic Blessings for her work on Our Lady of Guadalupe. (Courtesy Ana Pacheco.)

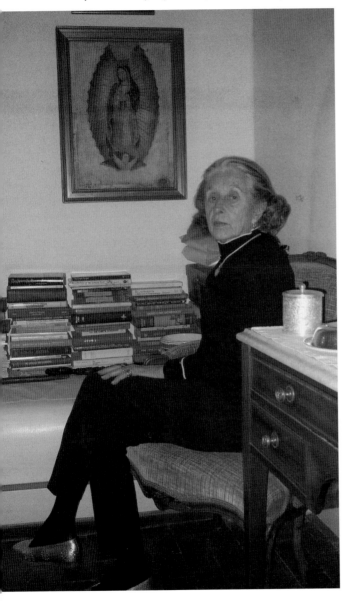

Pedro Ribera Ortega (1931–2003)
Ortega was the last editor of the Spanish-language newspaper *El Nuevo Mexicano* in 1958. He spent his teaching career at Santa Fe High School and contributed historical and cultural articles to many publications. A Santa Fe Living Treasure, Ortega was one of the founding members of Los Caballeros de Vargas and the *mayordomo* (caretaker) of La Conquistadora for 36 years. (Courtesy Connie Hernandez.)

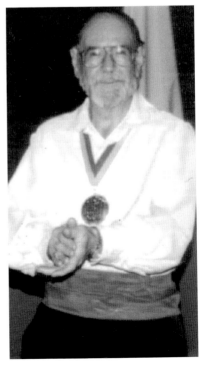

Nasario Garcia (1936–)

Garcia was born in Bernalillo, New Mexico. A former Spanish professor, he is the author of several books on New Mexico culture and is considered one of the state's most distinguished folklorists. In 2012, the Historical Society of New Mexico presented Garcia with the Lifetime Achievement Award "in recognition of his stellar contributions as an educator, community activist, and author of New Mexico History." (Courtesy Nedra Westwater.)

Marc Simmons (1937–)

Simmons has spent his writing career sharing New Mexico history with the masses. His weekly column, "Trail Dust," has been published in area newspapers for the last 25 years. Considered an authority on the Santa Fe Trail, his writings can be found in the National Geographic Society's volume of *Trails West*. Simmons, who is a past president of the Santa Fe Trail Association, is the author of 45 books. (Courtesy *Santa Fe New Mexican*.)

Martha Egan (1945–)
Egan grew up in Wisconsin and moved to New Mexico in 1974. She opened her Canyon Road gallery, Pachamama, Latin American Folk Art and Antiques, in 1988. Egan is the author of six books, four fiction titles, and two monographs. Her book *Milagros: Votive Offerings from the Americas*, is considered one of the definitive literary contributions to the area's cultural history. In addition to running her business and writing, Egan is a rabid Green Bay Packer fan. (Courtesy Carol Eastes.)

CHAPTER THREE

Art

Imagination is more important than knowledge.

—Albert Einstein

Native Americans were providing a narrative of history through art long before the first Spanish settlers arrived in New Mexico. Pottery remnants and other artifacts continue to be uncovered in and around Santa Fe. Sculptures by the late Allan Houser and by George Rivera, the current governor of Pojoaque Pueblo, are featured prominently in area museums and galleries. The sisters Geronima Montoya and Ramoncita Sandoval, two of the eldest members of Indian Market, continue as artists.

The Portuguese artist Carlos Vierra came to Santa Fe in 1904 and opened an art studio on the plaza. The architect John Gaw Meem's buildings throughout the region continue to define Santa Fe's unique architecture. In 1921, five young artists, Jozef Bakos, Walter Mruk, Willard Nash, William Schuster (the creator of Zozobra), and Fremont Ellis, joined creative forces and became known as Los Cinco Pintores (The Five Painters). Their modernistic art catapulted Santa Fe into an artist colony that today continues to draw artists from around the world. Georgia O'Keeffe, one of the most important female artists of the 20th century, first came to New Mexico in 1929. Today, the museum in Santa Fe that bears her name is the most widely visited cultural institution in the state. Jose Cisneros, the Mexican self-taught pen-and-ink illustrator, was awarded in 2002 the National Humanities Medal. Spanish Market artists Angelina Delgado, Monica Sosaya Halford, Arlene Cisneros Sena, and Eliseo and Paula Rodriguez, whose work has helped to foster the tradition of Spanish Colonial art, are all Santa Fe residents. The artist Faustin Herrera de Vargas, a beautician by trade, has captured village churches through his paintings, and Ford Ruthling's paintings highlighting the pottery of New Mexico pueblos became a series of US postage stamps in 1977. The sculptor Andrea "Drew" Bacigalupa runs the oldest continuously operating gallery on Santa Fe's famed Canyon Road, and Aron Gunther, who escaped the Holocaust, creates abstract menorahs as memorials to that horrific event in world history. Diana Bryer's art depicts the simplicity of northern New Mexico. And, last but not least, Tommy Maccione's memorable and colorful personality is surpassed only by his impressionistic paintings, sold in fine art galleries throughout the nation.

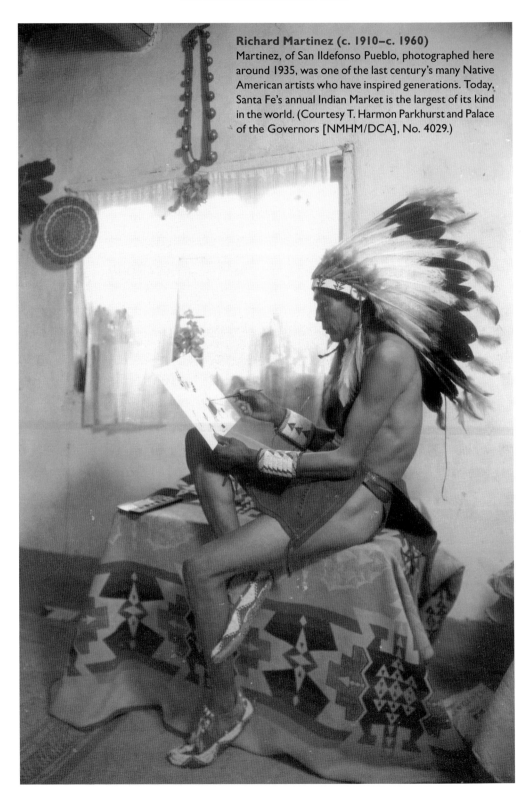

Richard Martinez (c. 1910–c. 1960)
Martinez, of San Ildefonso Pueblo, photographed here around 1935, was one of the last century's many Native American artists who have inspired generations. Today, Santa Fe's annual Indian Market is the largest of its kind in the world. (Courtesy T. Harmon Parkhurst and Palace of the Governors [NMHM/DCA], No. 4029.)

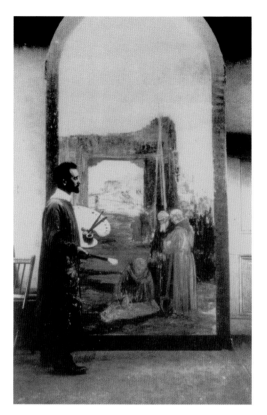

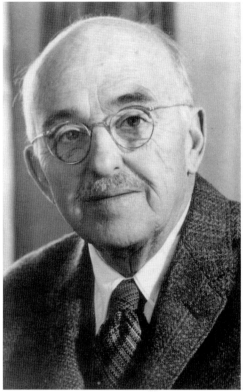

Carlos Vierra (1876–1937)
Vierra opened an art studio on the Santa Fe Plaza in 1904. A prolific artist and photographer, he collaborated with the School of American Research in the restoration of the Palace of the Governors in 1909. That was the beginning of his role in advocating for the Pueblo Revival architecture that has become synonymous with Santa Fe's unique landscape. (Courtesy Palace of the Governors [NMHM/DCA], No. 30856.)

John Gaw Meem (1894–1983)
Born in Pelotas, Brazil, Meem was working for an uncle, Jim Meem, who was an engineer building the New York City subway, when he contracted tuberculosis and moved to Santa Fe in 1920 to convalesce. Known as one of New Mexico's preeminent architects, Meem is credited for his creations of Pueblo Revival buildings. During his prolific period, from the 1930s through the 1950s, he designed several buildings on the University of New Mexico campus in Albuquerque and for the Colorado Fine Arts Center in Colorado Springs. In Santa Fe, he designed many structures, including Cristo Rey Church and the county courthouse. A number of his buildings are listed in the National Registry of Historic Places. (Courtesy Nancy Meem Wirth.)

Los Cinco Pintores

In 1921, five young men joined forces and became known for their work as artists of modernist art. Jozef Bakos(1891–1977), pictured on the right; Walter Murk (1895–1942), pictured below; Willard Nash (1898–1942); William Schuster (the creator of Zozobra) (1893–1969); and Fremont Ellis (1887–1985) introduced modernistic art in the Southwest. When they held their first exhibit at the Museum of Art in Santa Fe, the town's population was 7,000. (Courtesy T. Harmon Parkhurst and the Palace of the Governors (NMHM/DCA) No. 75793 and No. 32333.)

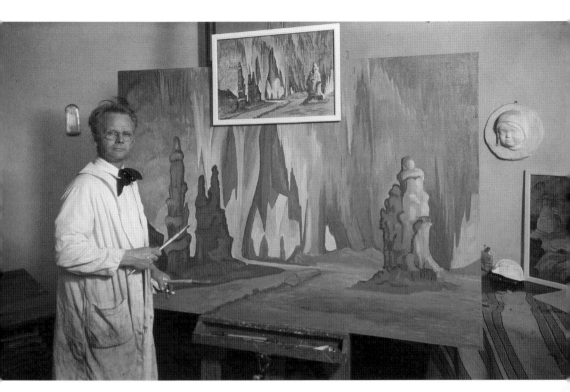

Santa Fe's Art Tradition

The group chose not only to work together, but also to live side by side. The members of Los Cinco Pintores built their adobe homes next to each other on Camino del Monte Sol, just off of Canyon Road, which today is known throughout the world for its art galleries. Their efforts placed Santa Fe on the map as an artist colony that continues to attract artists from around the world. Pictured above is Will Shuster. Willard Nash is pictured below on the left. Pictured below on the right, Fremont F. Ellis, the last of Los Cinco Pintores, died in 1985. (Courtesy T. Harmon Parkhurst and the Palace of the Governors [NMHM/DCA] No. 73983, No. 95287, and No. 131507.)

Georgia O'Keeffe (1887–1986)

O'Keeffe's love affair with New Mexico began in 1929, when she first visited the state. By 1940, she had purchased property in Abiquiu at Ghost Ranch, a sprawling 21,000-acre ranch run by the Presbyterian Church. In 1946, after the death of her husband, Alfred Stieglitz, who helped propel her career as one of the most important female artists of the 20th century, O'Keeffe moved permanently to her ranch in Abiquiu, where she spent the rest of her life. The artist's images of skulls and flowers have become ubiquitous representations of the American Southwest. The Georgia O'Keeffe Museum in Santa Fe is the most widely attended cultural institution in New Mexico. Her Abiquiu home and studio was designated a National Historic Landmark in 1998. When she died in 1986, her body, in accordance with her wishes, was cremated and her ashes scattered at the top of Pedernal Mountain, located in the expansive northern New Mexico vista immortalized in her paintings and often referred to as "O'Keeffe Country." (Courtesy John Candelario and the Palace of the Governors [NMHM/DCA], No.165660.)

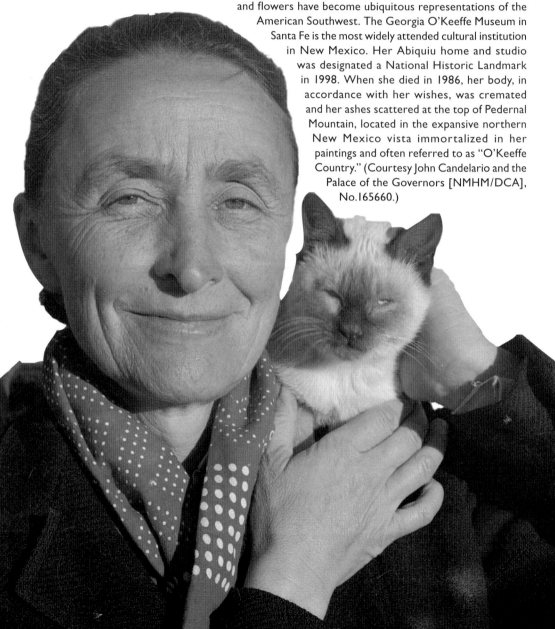

Allan Capron Houser (1914–1994)
The late sculptor and artist is considered one of the most important Native American artists of the 20th century. His work is displayed in collections in the Southwest, as well as in museums in the East, including the National Museum of American Art and the Museum of Indian Art in Washington, DC. His work is also found in the Japanese Royal Collection in Tokyo. Houser, a member of the Chiricahua Apache tribe, moved to Santa Fe in 1934. His wife, Anna Marie, celebrated her 100th birthday on August 7, 2012. (Courtesy Lee Marmon and Allan Houser, Inc.)

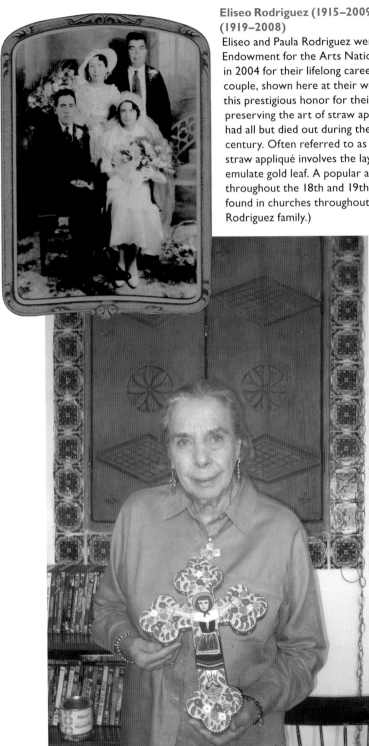

Eliseo Rodriguez (1915–2009) and Paula Rodriguez (1919–2008)

Eliseo and Paula Rodriguez were awarded a National Endowment for the Arts National Heritage Fellowship in 2004 for their lifelong careers as artists. The couple, shown here at their wedding in 1935, received this prestigious honor for their work in perfecting and preserving the art of straw appliqué, a technique that had all but died out during the early part of the 20th century. Often referred to as "poor man's gilding," straw appliqué involves the layering of straw to emulate gold leaf. A popular art form in New Mexico throughout the 18th and 19th centuries, it can be found in churches throughout the state. (Courtesy Rodriguez family.)

Monica Sosaya Halford (1929–)

Sosaya Halford is the daughter of Victoria and Augustin Sosaya, whose ancestors came to New Mexico in 1598. At 84 years of age, she is the oldest artist at the Santa Fe Spanish Market and currently mentors young children at the Spanish Colonial Art Museum. The award-winning artist is known for her *retablos* (Spanish paintings) of Santa Librada, the patron saint of liberated women. (Courtesy Ana Pacheco.)

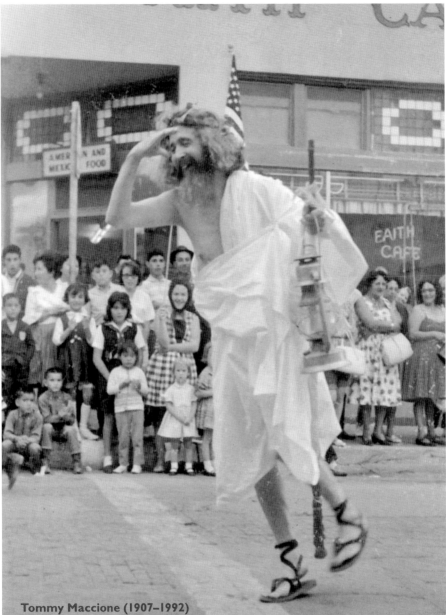

Tommy Maccione (1907–1992)
From his arrival in 1951, until he passed away four decades later, Maccione was known as "El Diferente." Rain or shine, the disheveled artist and his easel became regular fixtures around town. On more than one occasion, the authorities would pay a visit to his home after receiving numerous complaints about the menagerie of dogs and cats on his property. Unable to keep up with their care, the artist often traded his paintings for veterinary visits and pet food. Maccione also got involved in politics, running several times for mayor of Santa Fe and, one year, for US president. He also participated in the Santa Fe Fiesta parade in outlandish costumes that matched his colorful personality. Today, his impressionist paintings are sold in fine art galleries for thousands of dollars. (Courtesy Santa Fe New Mexican.)

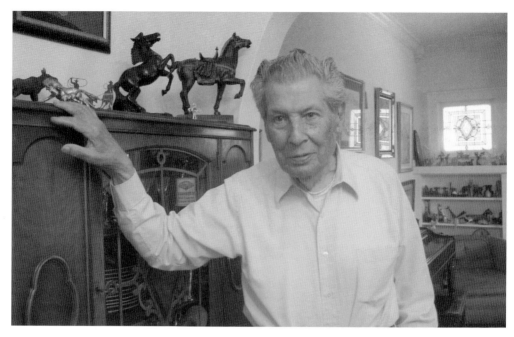

Jose Cisneros (1910–2010)

Cisneros was born in Mexico and lived most of his life in El Paso, Texas, but his artistic presence is felt in Santa Fe and beyond. He is considered the premier artist in this country to have illustrated aspects of Spanish Colonial history. His artwork is showcased at the Fray Angelico Chavez Library in Santa Fe and throughout New Mexico. With no formal instruction, the self-taught pen-and-ink illustrator has created thousands of illustrations that have appeared worldwide in books, magazines, and newspapers. Cisneros received more than 80 awards and citations for his artwork, the most prestigious being a National Humanities Medal in 2002. The Arlington National Cemetery uses his rendition of a military horseman in the certificate that it awards all graduates of the US Army Caisson Platoon. (Courtesy Ana Pacheco.)

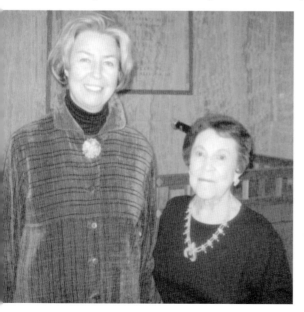

Angelina Delgado (1919–)

Delgado comes from a long line of tinsmith artisans. The work of her grandfather, Francisco Delgado, is on permanent display at the Smithsonian Institution in Washington, DC. As a teenager, Delgado took part in the WPA, the government-sponsored work program during the Great Depression. In 2008, Delgado (right) was honored at the 75th anniversary of the National New Deal Preservation Association for her contributions to the program by President Roosevelt's granddaughter, Anna Eleanor Roosevelt, at the state capitol. (Courtesy Angelina Delgado.)

Geronima Montoya (1915–) and Ramoncita Sandoval (1923–)
The sisters Geronima Montoya (right) and Ramoncita Sandoval are two of the oldest participants at Santa Fe's annual Indian Market. They were born to Pablo and Crucita Cruz at Ohkay Owingeh (San Juan Pueblo). Geronima's Native American name in Tewa is P'otsunu, which means "White Shell." Ramoncita's name is Poekwinsawin, which means "Terrace Lake." Both sisters have received lifetime achievement awards from the Santa Fe Indian Market and Santa Fe's Museum of Indian Arts and Cultural. Geronima has also received a lifetime achievement award from the Smithsonian Institution and was a Santa Fe Living Treasure in 2004. (Courtesy Ana Pacheco.)

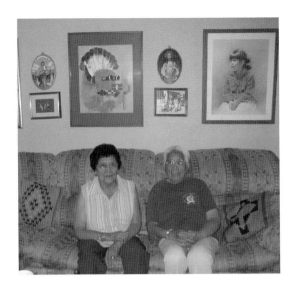

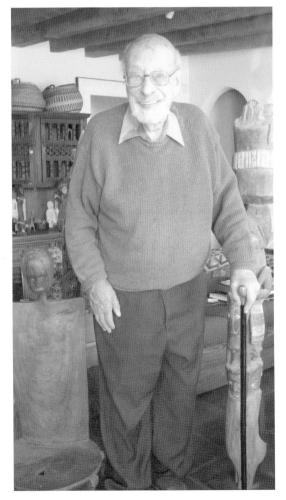

Peter T. Furst (1922–)
Furst is one of the nation's leading anthropologists on Mexico's Huichol Indians. In 1999, he moved to Santa Fe, where he and his colleague, the late Dr. Jill Gray, cocurated a two-year exhibition of art and artifacts at the Museum of Indian Arts and Culture. As a soldier during World War II, Furst was a war correspondent for the Army newspaper *Stars and Stripes Mediterranean.* After the war, he worked in Europe for the news service Reuters and for the CBS television network. (Courtesy Ana Pacheco.)

Gunther Aron (1923–)

Aron fled Nazi Germany in 1939, soon after his parents and his sister, Ruth, were killed in concentration camps. In the 1960s, he began making abstract menorahs in memory of his sister. They can be found in museums in Amsterdam, Berlin, New York, Chicago, and Los Angeles. In New Mexico, his menorahs are displayed at Temple Beth Shalom and the Capitol Art Collection at the State Roundhouse in Santa Fe, and at the Holocaust Museum in Albuquerque. In 1973, he and his wife, Geri, moved to New Mexico and currently reside in Santa Fe. (Courtesy Ana Pacheco.)

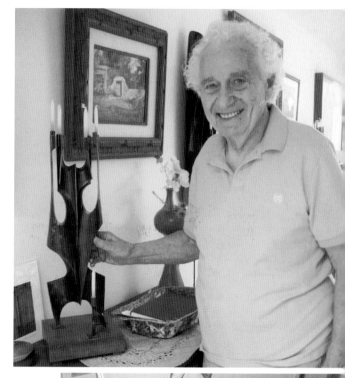

Andrea "Drew" Bacigalupa (1923–)

Bacigalupa is an artist, sculptor, ceramist, and writer. He opened the Bacigalupa Studio of Gian Andrea in 1956, which today is the oldest continuously operating gallery on Canyon Road. His religiously inspired works include a bronze statue of St. Francis in front of city hall, a ceramic tile mural of the prophet Elijah at Mt. Carmel at the Carmelite Chapel, a tile mural of San Francisco at the Episcopal Church of the Holy Faith, and etched glass panels at the Cathedral Basilica of St. Francis of Assisi. (Courtesy Ana Pacheco.)

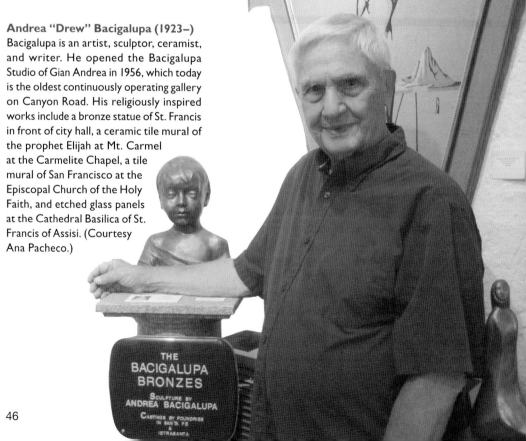

THE
BACIGALUPA
BRONZES

SCULPTURE BY
ANDREA BACIGALUPA

CASTINGS BY FOUNDRIES
IN SANTA FE
&
PIETRASANTA

Ford Ruthling (1934–)

Ruthling was born 30 minutes before his fraternal twin brother, Carleton, at St. Vincent Hospital. He decided early on to be an artist and was a student of Jozef Bakos, one of Los Cinco Pintores, who taught art at Santa Fe High School. Ruthling's art had been showcased at the Smithsonian Institution in Washington, DC, the Dallas Museum of Fine Art, the Museum of New Mexico, and in galleries throughout the world. In 1977, his paintings highlighting the pottery from New Mexico's Acoma, Hopi, Zia, and San Ildefonso Pueblos became a series of US postage stamps. He was named a Santa Fe Living Treasure in 1993. The 1944 photograph on the right shows Ford Ruthling (left) with his twin brother, Carleton, and Marcelo Herrera of Tesuque Pueblo. (Left, courtesy Herb Lotz; right, courtesy Ford Ruthling.)

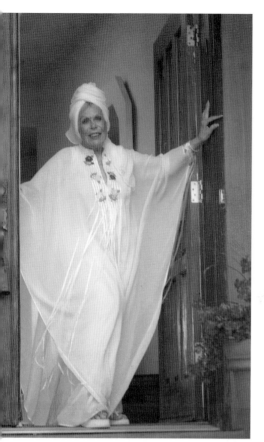

Rebecca Welles (1928–)
Welles was married to the late film and television director Don Weis. In 1990, the couple moved to Santa Fe and Welles became a ceramist, creating cultural designs for the State of New Mexico that were sold at Harrods in London, the Galleries Lafayette in Paris, and department stores around the United States. (Courtesy Linda Carfagno.)

George Rivera (1964–)
Rivera, born in Santa Fe, is a member of the Pueblo of Pojoaque. His sculptures and paintings can be found in public and private collections like the Smithsonian Institution in Washington, DC, and the pueblo's Buffalo Thunder Casino. The current governor of the Pueblo of Pojoaque, Rivera oversees economic and community development integrating traditional arts with education. (Courtesy George Rivera.)

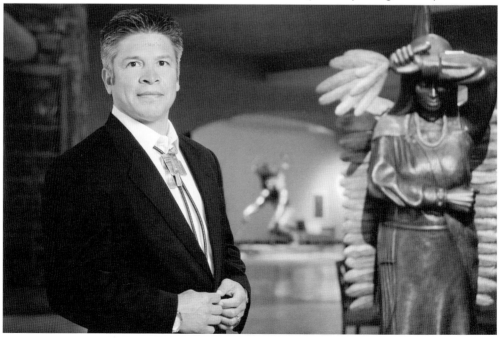

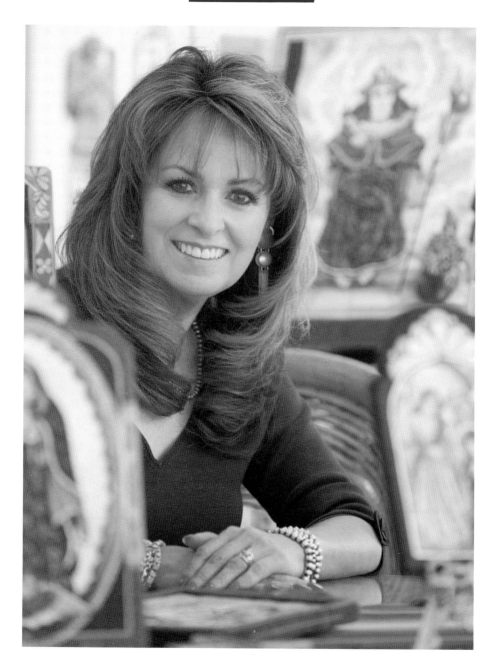

Arlene Cisneros Sena (1952–)
Cisneros Sena received the Master's Award for Lifetime Achievement from the Spanish Colonial Arts Society in 2012. Her work can found at churches throughout the country, including the Basilica of St. Francis Cathedral of Assisi and the Shrine of Our Lady of Guadalupe in Santa Fe. In 2011, she completed six original retablos at the Shrine of Our Lady of Guadalupe depicting the 1531 story of the Aztec Indian, Juan Diego, who experienced the apparition of Our Lady of Guadalupe, Mexico's revered Madonna. The images have been replicated as tile murals lining the outdoor spiritual walkway of Our Lady of Guadalupe Parish. (Courtesy Corrie Photography.)

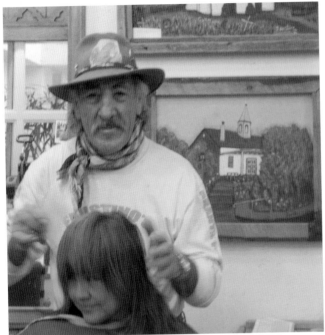

Faustino Herrera de Vargas (1934–)
Herrera De Vargas was born in La Madera, a small village between Taos and Chama, New Mexico. He moved to Santa Fe in 1968 and opened his first beauty salon, a trade that he has continued for the last 40 years. In 1991, while running his salon at La Fonda Hotel, Herrera de Vargas decided it was time to make a change. He became a self-taught artist. For the last 22 years, he has painted over 700 churches in the villages of New Mexico, all the while continuing his trade as a beautician. (Courtesy Ana Pacheco.)

Diana Bryer (1942–)
Bryer was born in Los Angeles and moved to northern New Mexico in 1977. A self-taught artist, she was drawn to the rich traditions and spirit of the area's Spanish and Native peoples, including many of Sephardic Jewish ancestry. For more the last 50 years Bryer has been creating art that transcends cultural barriers and unifies all people. (Image by aj Melnick.)

CHAPTER FOUR

Entertainment

There's no business like show business.

—Irving Berlin

For the past 87 years, nearly everyone in Santa Fe has taken part in the annual celebration of the burning of Zozobra, "Old Man Gloom," at Fort Marcy Park during the annual Fiesta de Santa Fe. And since 1956, people from around the world have enjoyed professional opera at the Santa Fe Opera. Wise Fool New Mexico has stirred the imagination of citizens with their annual production, Circus Luminous. Individuals that have made their mark in Santa Fe in the performing arts include Pablo Mares, who wrote New Mexico's bilingual state song, "Mi Lindo Nuevo Mexico," and K.D. Edwards, who performed internationally for several decades with Indian dance troupes. Antonio Mendoza is a classical guitarist and painter, and Robert Lussier is an actor-turned-priest. Singer Genoveva Chavez was known as the "First Lady of the Santa Fe Fiesta," and the storyteller Joe Hayes, cinematographer Alton Walpole, salsa musician and Catholic priest Father Frank Pretto, and actors Wes Studi and David Huddleston are all a part of the community's reputation for performing arts. The Benitez family, Cecilio, Maria, and Francisco, have integrated the Spanish arts into the life of Santa Fe. Godfrey Reggio, the award-winning documentarian, has shared his abstract vision of today's society, and the designer, ceramist, and actress Rebecca Welles advocates for many artistic groups in Santa Fe. The television writer Claire Whitaker wrote the popular series The Waltons and Falcon Crest in the 1980s, and Imogene Hughes is the proprietor of the Bonanza Creek Ranch, where major motion pictures are filmed each year. The musicians Doug Montgomery, Jerry Lopez, and Todd Eric Lovato strive to entertain. Film executive Eric Witt, radio host Mary-Charlotte Domandi, playwright Eliot Fisher, and Jacques Paisner, the executive director and cofounder of the Santa Fe Independent Film Festival, contribute to the foundation of Santa Fe's entertainment industry.

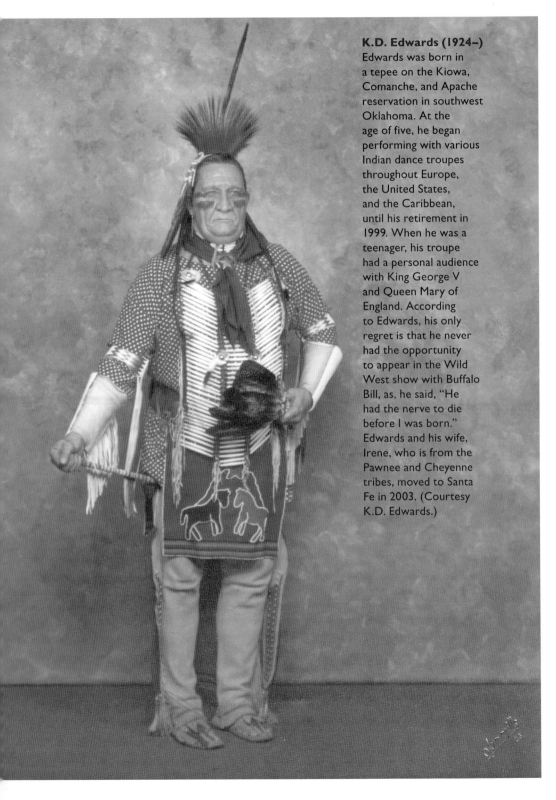

K.D. Edwards (1924–)
Edwards was born in a tepee on the Kiowa, Comanche, and Apache reservation in southwest Oklahoma. At the age of five, he began performing with various Indian dance troupes throughout Europe, the United States, and the Caribbean, until his retirement in 1999. When he was a teenager, his troupe had a personal audience with King George V and Queen Mary of England. According to Edwards, his only regret is that he never had the opportunity to appear in the Wild West show with Buffalo Bill, as, he said, "He had the nerve to die before I was born." Edwards and his wife, Irene, who is from the Pawnee and Cheyenne tribes, moved to Santa Fe in 2003. (Courtesy K.D. Edwards.)

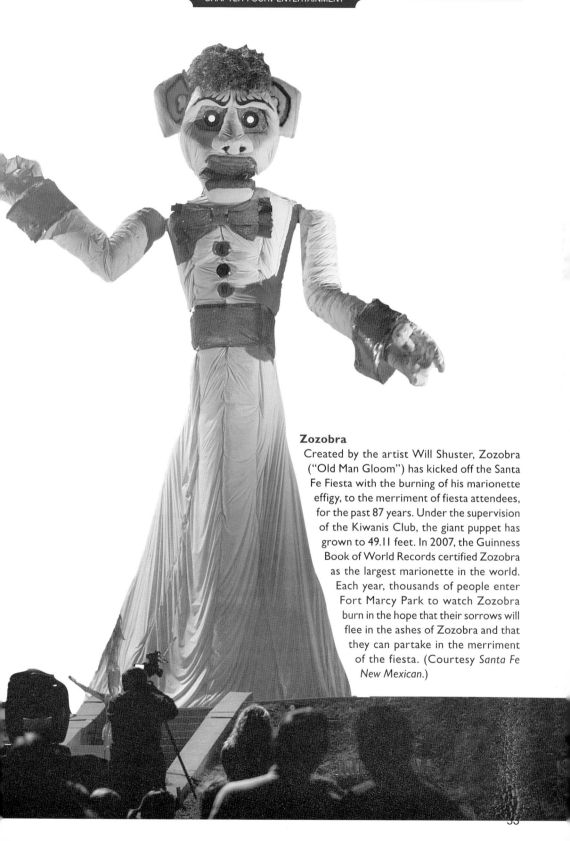

Zozobra
Created by the artist Will Shuster, Zozobra ("Old Man Gloom") has kicked off the Santa Fe Fiesta with the burning of his marionette effigy, to the merriment of fiesta attendees, for the past 87 years. Under the supervision of the Kiwanis Club, the giant puppet has grown to 49.11 feet. In 2007, the Guinness Book of World Records certified Zozobra as the largest marionette in the world. Each year, thousands of people enter Fort Marcy Park to watch Zozobra burn in the hope that their sorrows will flee in the ashes of Zozobra and that they can partake in the merriment of the fiesta. (Courtesy *Santa Fe New Mexican*.)

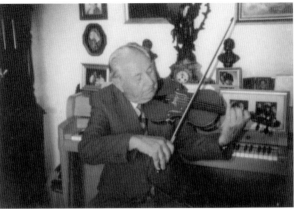

Pablo Mares (1913–2004)
Mares started Tipica Orchestra during the Great Depression and spent 35 years as music educator. In the 1950s, he was the band director at Santa Fe High School; during this time, he performed with his own string orchestra, which became well known for its renditions of New Mexico folk music. In 1995, New Mexico adopted his 1947 song "Mi Lindo Nuevo Mexico" as the official bilingual state song. In addition to his Hispanic music and arrangements, Mares also wrote 80 country-and-western songs. (Courtesy Maria E. Naranjo.)

Claire Whitaker (1928–)
Whitaker wrote for television for more than 40 years with her late husband, Rod Peterson. Their most popular shows were The Waltons and Falcon Crest in the 1980s. The couple moved to Santa Fe in 1989. Today, Whitaker raises money and awareness for ALS (amyotrophic lateral sclerosis), the disease that killed her son, the television producer Ernest Wallengren, in 2003. (Courtesy Claire Whitaker.)

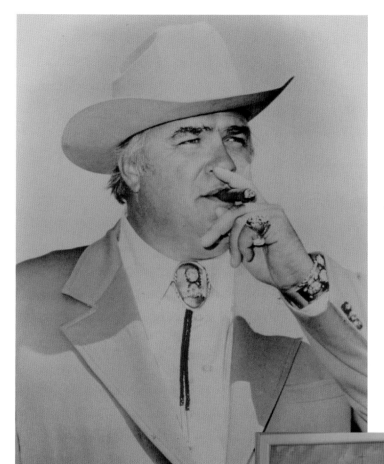

David Huddleston (1930–)
Huddleston moved to Santa Fe in 1988 after working for more than 50 years as an actor. His movie credits include Rio Lobo, Fools Parade, Family Reunion, Billy Two Hats, Frantic, and the cult film The Big Lebowski, directed by Joel and Ethan Coen. In that film, Huddleston played the wheelchair-bound millionaire, Big Lebowski. (Courtesy David Huddleston.)

Antonio Mendoza (1931–)
Mendoza was born at the railroad station in Ignacio Allende in the state of Durango, Mexico. His first cradle was a bench and a sack of straw, and he was given the name Xmatori by his father, who was a Huichol Indian. Mendoza is well known throughout the country as a classical guitarist, and he is also an artist and has his own commercial studio on Balboa Road in Santa Fe. (Courtesy Ana Pacheco.)

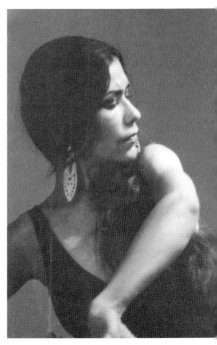

Cecilio (1930–), Maria (1950–), and Francisco Benitez
Santa Fe is home to the creative force of the Benitez family, who for the past 40 years have fostered Spanish culture and European art in the community. Cecilio Benitez (left) was born in Barcelona. When he was 14, he began his career in the theater as a set designer and director. He later went on to manage his wife's international career of dance and art. Maria Benitez (above) was born in Taos. She spent several decades performing flamenco around the world. In 2006, she received Spain's most prestigious award, La Cruz de la Orden de Isabel la Catolica, for her successful efforts at introducing the masses to the art of Spanish dance. Maria is the founder and director of the Institute of Spanish Arts in Santa Fe. The couple's only son, Francisco Benitez, was born in Santa Fe. (Courtesy Maria Benitez.)

Francisco Benitez (1967–)

As a young boy, Francisco (below) traveled extensively with his parents while his mother performed around the world. As a teenager, he came to appreciate the roots of flamenco music, and this, combined with the backdrop of the theater, caused his own aspirations as an artist to take root. Inspired by Michelangelo Mersi da Caravaggio, of the 17th-century Baroque school, Francisco Benitez approaches contemporary art with classical realism. He has a successful career specializing in Renaissance art and divides his time between Santa Fe and Europe. (Courtesy Linda Carfagno and Ana Pacheco.)

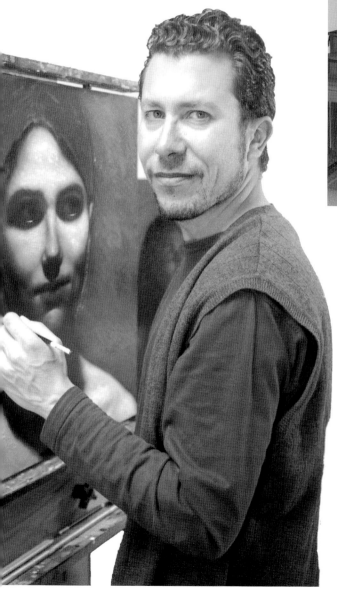

Imogene Hughes (1933–)

Hughes runs the sprawling, 1,200-acre Bonanza Creek Ranch south of Santa Fe. In addition to raising cattle, she runs a bustling movie business that includes six permanent sets where movies like Cowboys and Aliens have been filmed. Since 1982, when the film Silverado was shot at the ranch, Hughes and her late husband, Glenn, have leased their property and sets—one of which is a western motif, with three homesteads, a town, and a fort—to film and television studios around the world. (Courtesy Ana Pacheco.)

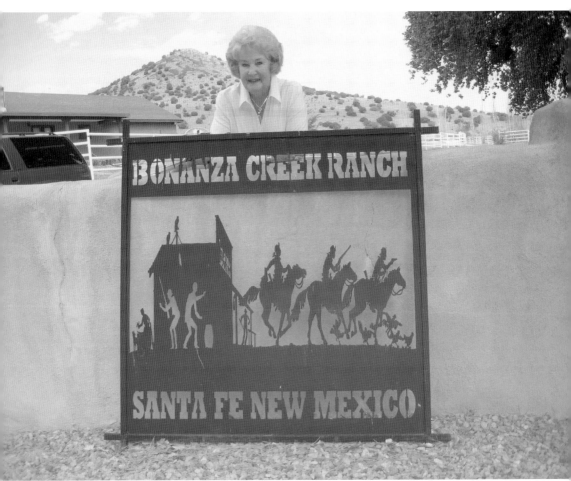

Nancee Cortes (1935–)
Cortes was born in Denver. As a young girl, she studied classical dance under the tutelage of Ivan Novikoff and Lillian Cushing. In 1953, she headed to New York, where she took classes with Robert Joffrey, Rudolph Nureyev, Dame Margot Fontaine, and Eric Bruhn. Later, she became a choreographer at Radio City Music Hall, the Connecticut Dance Academy, and at the University of Southern California and the University of Utah. Cortes moved first to Santa Fe in 1993, because she felt a strong connection from her first visit, at the age of five, when she experienced Native American dances and Spanish music at the Santa Fe Fiesta. (Above, courtesy Ana Pacheco; left, courtesy Nancee Cortes.)

Robert Lussier (1934–)

Lussier was born in West Warwick, Rhode Island. In 1963, he became an actor and made a living doing television commercials. He moved to Los Angeles in 1969, and for the next 24 years acted in popular television serials. A devout Catholic, Lussier was ordained a Catholic priest in 1992. Today, Father Bob is very happy doing God's work as a priest at the Carmelite Monastery, the Cathedral Basilica of St. Francis of Assisi, and Cristo Rey Church in Santa Fe. (Courtesy Fr. Bob Lussier.)

Godfrey Reggio (1940–)

Reggio was born in New Orleans and came to Santa Fe as a member of the Christian Brothers. In the early 1960s, he cofounded La Clinica de la Gente, a medical clinic for the barrios of northern New Mexico, and Young Citizens for Action, which helped to thwart youth gang violence. Not long after working with these organizations, Reggio left the religious order and went on to become one of America's most prominent experimental documentary filmmakers. His award-winning Qatsi trilogy explores the complexities of living. All three titles of the trilogy derive from the Hopi language: *Koyannisqatsi* (life out of balance), *Powaqqatsi* (life in balance), and *Naqoyqatsi* (life as war). Reggio is currently working on a new film, *The Holy See*, with Philip Glass as the composer and Jon Kane as the visual designer. (Courtesy Linda Carfagno.)

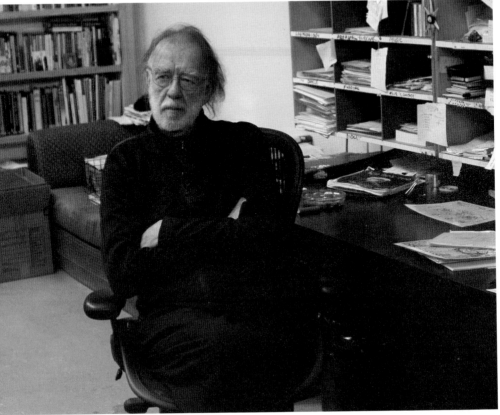

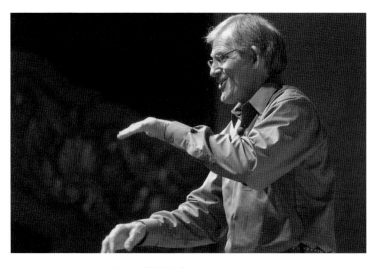

Joe Hayes (1945–)

Hayes, a former schoolteacher, is the resident storyteller at the Wheelwright Museum of the American Indian. For the past 31 years, he has captured the essence of American Southwest history by providing lively narratives of the Anglo, Native American, and Hispanic peoples. He credits his success to audience involvement and in keeping his presentations short and succinct— his longest presentation is 25 minutes. Hayes is also the author of 24 bilingual children's books. (Courtesy *Santa Fe New Mexican.*)

Genoveva Chavez (1942–1997)

Chavez was known as the "First Lady of the Santa Fe Fiesta" for her annual musical performances at the community event. She began singing at weddings and other family celebrations when she was five. By the time she was a young woman, her career was in full bloom, and she performed with several mariachi groups and Mexican stars, including Lucha Villa, Lola Beltran, Vicente Fernandez, and Jose Alfredo Jimenez. Santa Fe's largest sports complex is named in her honor. (Courtesy Herb Lotz.)

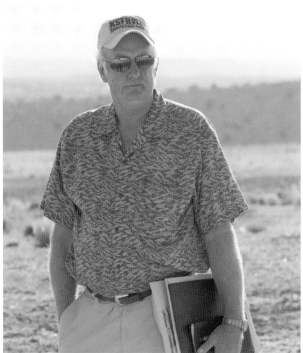

Alton Walpole (1946–)

In the last 31 years, Walpole has earned a reputation as an eclectic filmmaker for his work as a cinematographer, editor, and producer. His most recent work, all shot in New Mexico, includes *Crazy Heart*, *The Book of Eli*, and the A&E series *Longmire*. Walpole, who is a Santa Fe resident, is a member of the Directors Guild of America and the owner of Mountainair Films, a full-service production company. (Courtesy Alton Walpole.)

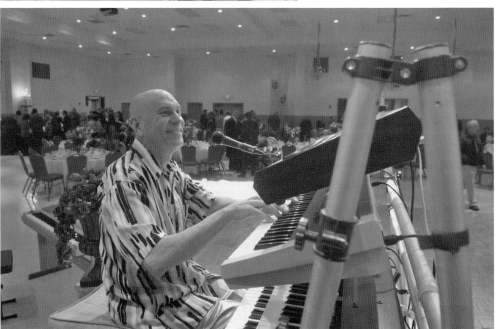

Fr. Frank Pretto (1946–)

Pretto, who was born in Panama, has been the pastor at San Isidro Church in Santa Fe since 1982. In between his church duties, he has performed with his band Pretto Y Paranda throughout Santa Fe and Albuquerque. He began playing the keyboards at the age of 14 in Panama and has recorded three albums, including Live, En Vivo with Pretto in 2012. (Courtesy *Santa Fe New Mexican*.)

Wes Studi (1947–)

Cherokee actor Wes Studi was born in Nofire Hollow, Oklahoma, and has lived in Santa Fe since 1993. A Vietnam War veteran, activist, Native language advocate, horseman, sculptor, and musician, he is best known for performances in The Last of the Mohicans, Geronimo: An American Legend, Heat, Avatar, and his portrayal of Tony Holliman's Det. Joe Leaphorn for PBS Mystery. He received the Governors Award for Excellence in the Arts in 2010. (Courtesy Linda Carfagno.)

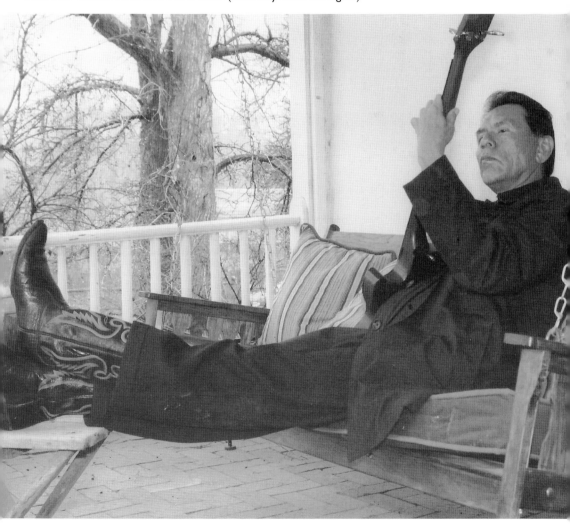

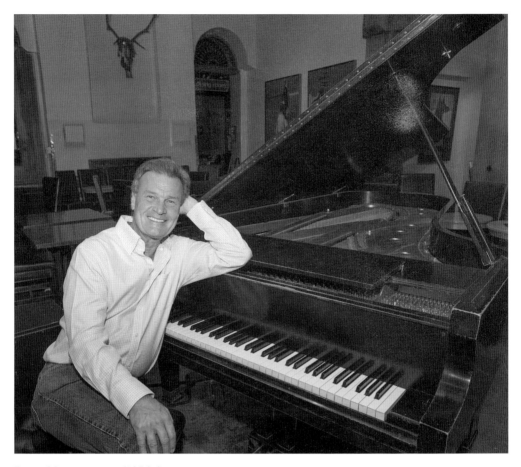

Doug Montgomery (1954–)
Montgomery is a classically trained pianist who has delighted audiences with his renditions of popular music at Vanessie of Santa Fe since 1983. The award-winning Chicago native received his master's degree from Juilliard. He has recorded and produced 15 CDs of different genres of music during his career. In addition to his gig at Vanessie's, he regularly hits the road, performing at venues throughout the world. In 1989, he performed at several inaugural events at the personal request of the newly elected president, George H.W. Bush. (Courtesy Daniel Driensky.)

Jerry Lopez (1956–) (OPPOSITE PAGE)
Lopez was born on Santa Fe's west side and began performing with his older brother, Gilbert, when he was two years of age. Under the direction their father, Gilbert Lopez Sr., the Lopez Brothers recorded 15 albums of mariachi music by the time they were teenagers. The duo performed in the early 1970s as strolling troubadours with the late flamenco artist Vicente Romero and, later, their younger brother Lenny became part of the group, known throughout Santa Fe as Los Hermanos Lopez. Today, Lopez is a professional musician, composer, bandleader, and musical director and has his own band, Santa Fe and the Fat City Horns, in Las Vegas, Nevada. Jerry is pictured as a young mariachi with his brother Gilbert Lopez Jr. (holding guitar). (Courtesy Jerry Lopez.)

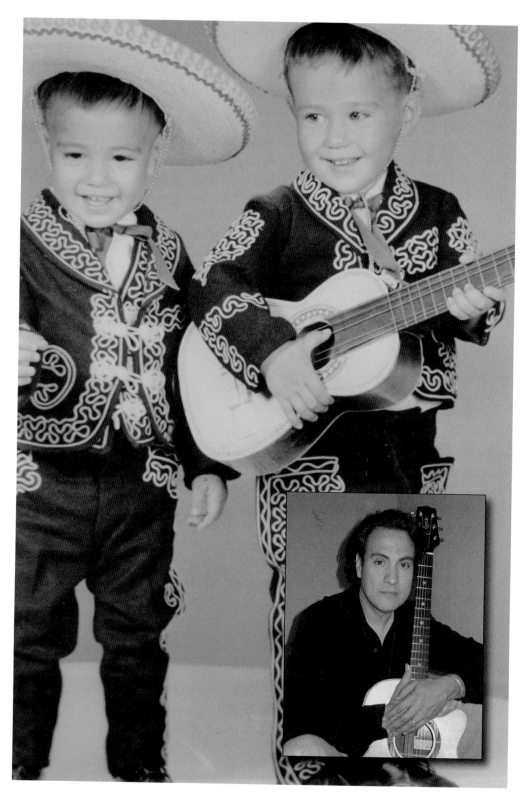

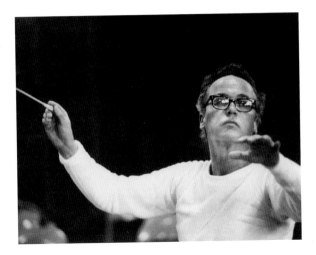

Santa Fe Opera

The Santa Fe Opera is synonymous with summer in Santa Fe. Founded by John Crosby in 1956, the world-renowned opera in the high mountain desert of the American Southwest, seven miles north of Santa Fe, is home to professional musicians who perform both classic and new opera productions. Crosby, who died in 2002, conducted many operas throughout his career. (Courtesy Santa Fe Opera.)

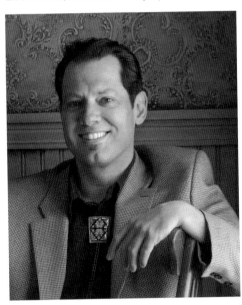

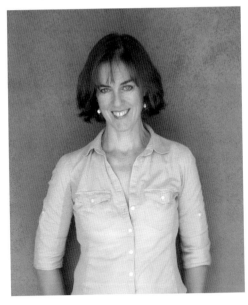

Eric Witt (1962–present)

Witt headed legislative affairs for Gov. Bill Richardson, whose administration achieved unprecedented economic growth from 2003 to 2011. A former production executive, Witt also oversaw the transformation of the state's once-intermittent film and television industry into a multibillion-dollar operation. (Courtesy Eric Witt.)

Mary-Charlotte Domandi (1971–)

Domandi is the award-winning producer and host of *Santa Fe Radio Café* on KSFR 101.FM. A graduate of Yale University and St. John's College, Domandi interviews people on topics ranging from literature and the arts, to politics, science, and environmental issues—all from a corner table at the Santa Fe Baking Company. A student of Cuban social and folkloric music and dance, Domandi is also a Latin music DJ. (Courtesy Mary-Charlotte Domandi.)

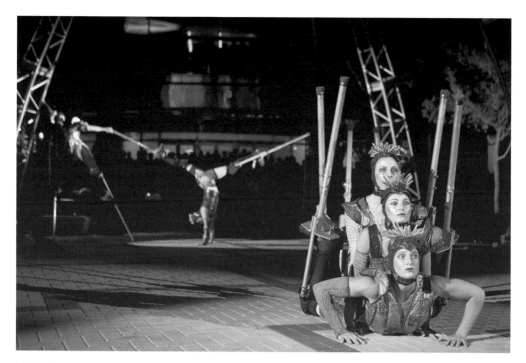

Wise Fool New Mexico

Wise Fool New Mexico (WFNM) was created in 1998 by a group of women artists/activists working to ignite imagination, build community, and promote social justice through performances and hands-on experiences in the arts of circus, puppetry, and theater. Their belief is that the process of learning circus skills and puppetry instills self-confidence and healthy body image, teaches teamwork and mutual respect, and encourages trust in oneself and others. Best known locally for their annual production Circus Luminous, WFNM's professional productions draw people into a common experience of awe and beauty, provoking dialogue with insightful perspectives on shared humanity. Wise Fool is shown here performing "Flexion," an outdoor aerial stilt spectacle. (Courtesy Kate Russell.)

Todd Eric Lovato (1979–)

A Santa Fe native, Lovato is the managing editor of SantaFe.com, where he facilitates some 40 community bloggers, a dynamic editorial and multimedia staff, and the Web presence of six radio stations. He is a member of the City of Santa Fe Arts Commission and a songwriter, producer, and independent record label founder. Lovato has received five New Mexico Music Industry Awards and is the bandleader of Todd & the Fox, which performs concerts throughout the Southwest. In the fall of 2012, the group performed in South Korea. (Courtesy Todd Eric Lovato.)

Jacques Paisner (1980–)

Paisner is the executive director and cofounder of the Santa Fe Independent Film Festival. Born in Minneapolis, he grew up in Oregon, the Navajo Nation, and graduated from Santa Fe High in 1998. He is the author of Albuquerque Blues 2007, and was the writer and director of the 2009 feature film *Rejection*. Paisner currently serves on the board of directors for the Santa Fe Railyard Community Corporation. (Courtesy Jacques Paisner.)

Eliot Fisher (1983–)

Fisher was born in Boston and came to Santa Fe with his parents when he was an infant. He is a multimedia producer and teaches at Santa Fe Prep, where he's also an alumnus. He has bachelor's degrees in film studies from Wesleyan University and documentary studies from the College of Santa Fe. He has composed music for short films and live performance and has written 11 original theater productions with music, many of which he also directed. Among these shows are several melodramas that were performed at the Engine House Theater in Madrid, New Mexico, and the Santa Fe Playhouse. (Courtesy Eliot Fisher.)

CHAPTER FIVE

Sports

If you want a place in the sun,
prepare to put up with a few blisters.

—Abigail Van Buren

Nothing depicts the spirit of Santa Fe more than those residents with a competitive spirit who have brains, brawn, and the talent to excel in sports. Until Santa Fe's Capital High School opened in 1975, the ongoing, 87-year sports rivalry between St. Michael's High School and Santa Fe High School dominated local sports. During the early part of the 20th century, Henry "Kid" Pacheco was a local boxing hero who won a series of Armed Forces titles, including the bantam championship of the Hawaiian Islands and bantamweight championship of the Pacific Fleet. Jim Kennicott, a big-game hunter, followed the same route that Teddy Roosevelt once hunted in Kilimanjaro. Tove Shere, has competed on the 7 Team USA World Championship and holds two national titles in cyclocross. The late Marty Sanchez was an avid golfer, and Santa Fe's main golf course is named in his honor. Since 1949, the Rodeo de Santa Fe has delighted audiences with western cowboy competitions. Henry McKinley, the cowboy rancher, reigned as the New Mexico State calf-roping champion for many years. Two basketball legends, Nick Pino and Toby Roybal, both of whom caught the attention of professional leagues, are still remembered in Santa Fe. Julie Endreson is a physical trainer who for the last 20 years has volunteered for the USA Track and Field Association. An athletic scholarship is named for Charles "Cocoa" Maxwell, who committed suicide in 1989. Bill Garcia has been a volunteer couch for youth baseball, football, and soccer for the past 40 years. And Jannine Cabossel is a Master Gardener who holds three New Mexico State records for her giant vegetables, including a 448-pound giant pumpkin.

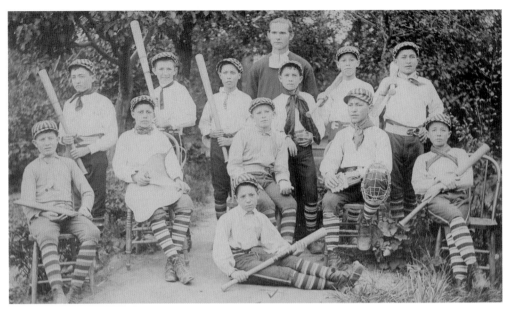

St. Michael's High School and Santa Fe High School

Until Santa Fe's Capital High school opened in 1975, the ongoing rivalry between St. Michael's High School (est. 1859) and Santa Fe High School (est. 1889) dominated city sports. Above is the St. Michael's High School 1890 baseball team. Pictured below is the Santa Fe High School girl's basketball team in 1917. (Above, courtesy Palace of the Governors [NMHM/DCA], No. 050262; below, courtesy Norma Fiske and Palace of the Governors [NMHM/DCA], No. 0707255.)

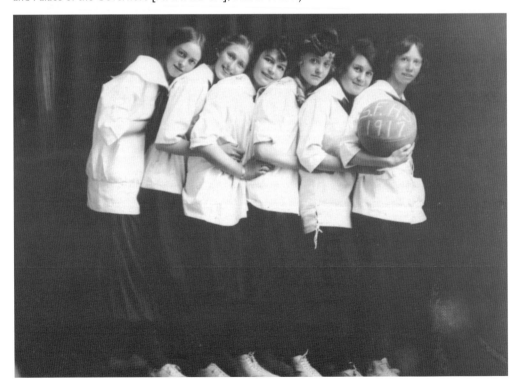

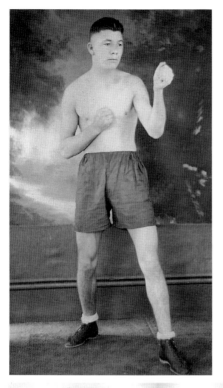

Henry "Kid" Pacheco (1900–1958)

Pacheco was seven when he slipped on his first pair of boxing gloves and began challenging neighborhood children in Santa Fe. When he was 15, he made his boxing debut in Madrid, New Mexico, at the annual Fourth of July celebration. At 19, he joined the Marines and went on to a series of Armed Forces titles, including the bantam championship of the Hawaiian Islands and bantamweight championship of the Pacific Fleet. When he returned to Santa Fe as a civilian, his biggest feat came in 1923, when he knocked out an opponent that was 70 pounds heavier. Pacheco was ecstatic with his winnings of $50 and the fact that a crowd of fans carried him to the Mayflower Café in downtown Santa Fe to celebrate his momentous victory. In the photograph below, Pacheco is the first person on the left in the first row. (Both, courtesy Ernie Pacheco.)

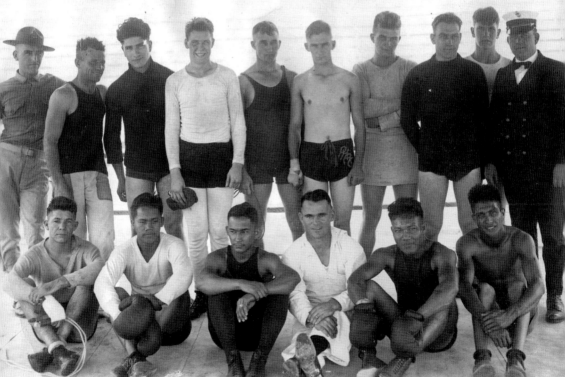

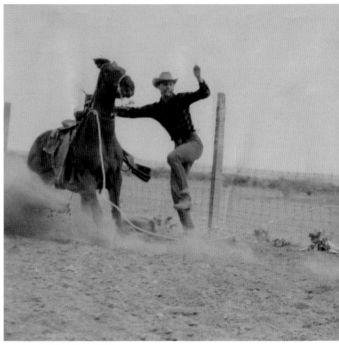

Henry McKinley (1928–)
McKinley is the last of a dying breed of professional cowboys and ranchers in New Mexico. He and his wife, Peggy, manage the Rancho Viejo, a 30,000-acre ranch and herd of Longhorn cattle south of Santa Fe. For many years, McKinley held the New Mexico state title in calf-roping. The 1952 photograph on the right shows McKinley during a roping competition at the New Mexico College of Agriculture and Mechanic Arts, known today as New Mexico State University. (Courtesy Henry McKinley and Ana Pacheco.)

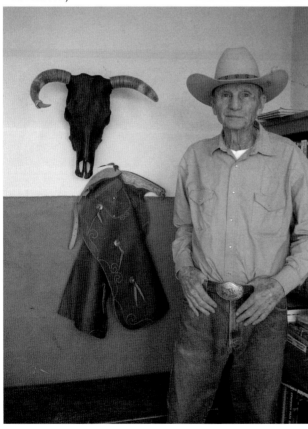

Jim Kennicott (1928–)

Kennicott comes from a long line of pioneers that came over on the Mayflower. The exploration by his great-great uncle, Robert Kennicott, led to Alaska becoming the 49th state of the union. In Glenview, Illinois, the Kennicott Grove National Historic Landmark was named for his great-uncle, Dr. John Kennicott, who was a physician and horticulturist. Like his ancestors, Kennicott has a pioneering spirit, and during his prime was an avid big-game hunter. A fan of Teddy Roosevelt, in 1976 he shot a water buffalo in Kilimanjaro, Africa, following the same route that Roosevelt once hunted. (Courtesy Jim Kennicott.)

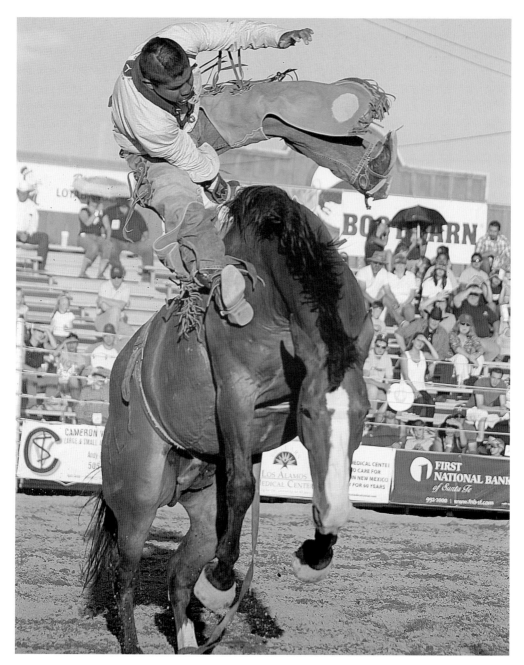

Rodeo de Santa Fe

The Rodeo de Santa Fe has entertained generations of fans for the past 64 years. A member of the Professional Rodeo Cowboys Association, it is one of the few ongoing rodeos in the nation that preserves western-style cowboy sportsmanship. The dream to incorporate aspects of rodeo competition, from bronco riding to calf-roping, began in 1949 with a group of kindred spirits: Roy Butler, Austin "Slim" Green, Gene Petchesky, Paul Ragle, and other enthusiastic members who had the gumption to organize a professional rodeo in Santa Fe. Today, the Rodeo de Santa Fe is listed as one of the leading members of the Professional Rodeo Cowboys Association. (Courtesy *Santa Fe New Mexican*.)

Toby Roybal (1932–1962)

Roybal was a four-sport letterman at Santa Fe High School who received a scholarship to play basketball at the University of New Mexico. He earned all-conference honors and set several scoring records for the UNM Lobos. He received invitations from the NBA to play professional basketball, but chose, instead, to become a teacher in 1959 at B.F. Young Junior High in Santa Fe. He died prematurely at the age of 30 of lymphatic cancer. In 1977, Santa Fe High School named its new gymnasium in his honor. In 1984, Roybal was inducted into the Albuquerque Sports Hall of Fame and the UNM Hall of Honor. (Courtesy Lenny and Roger Roybal.)

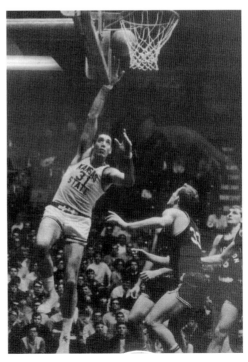

Nick Pino (1945–)

Pino was a member of St. Michael's High School's undefeated basketball team in 1962 that was dubbed the "Mighty Midgets." All of the team members were under six feet tall, with the exception of Pino, who was a towering 6 feet, 10 inches. After graduation, Pino received a basketball scholarship to Kansas State, and in 1967 and 1968, was recruited to play basketball for the Los Angeles Lakers. Today, at 7 feet, 1 inch, he runs his own insurance agency and keeps abreast of local sports, especially at his alma mater, St. Michael's. (Courtesy Nick Pino.)

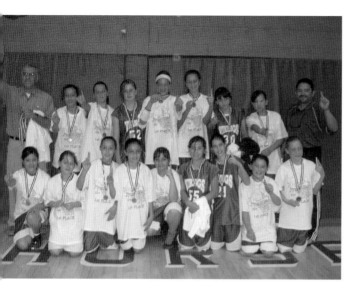

Bill Garcia (1950–)

Garcia, a Santa Fe native, has been interested in youth athletics ever since he was a member of the St. Francis basketball team in 1964. Since 1972, Garcia has been a volunteer coach at city public schools for baseball, basketball, and soccer teams. In 2011, he was awarded the St. Francis of Assisi Award for his volunteer work with the youth community at the Basilica of St. Francis of Assisi Cathedral. Garcia (second row, far left) is shown here with the 2008 sixth-grade girls Vikings basketball team. Ivan Trujillo, assistant coach, is in the second row, far right. (Courtesy Bill Garcia.)

Tove Shere (1952–)

Shere was born in England and immigrated to Canada in 1957. She moved to New York City in 1973 and came to Santa Fe in 1976. In 1987, she moved to San Diego and returned to Santa Fe in 1994. Shere has competed on the 7 TEAM USA World Championships in both duathlon and triathlon, and she holds two national titles in cyclocross. For the past 15 years, she has worked at Santa Fe Preparatory School as the track and field head coach for boys and girls. (Courtesy Tove Shere.)

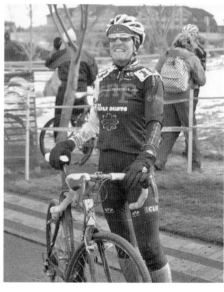

Julie Endreson (1952–)

Endreson was born in Sioux Falls, South Dakota, and moved to Santa Fe in 1991 from Los Angeles. The owner of Santa Fe Sports Medicine and Rehabilitation at El Gancho, Endreson is a certified athletic trainer, physical therapist assistant, and a licensed massage therapist. After receiving her master's degree from the University of Oregon, she got her first job in sports medicine at a clinic in Los Angeles. Her boss, Gail Weldon, was connected to USA Track and Field, and that's where, for the last 20 years, Endreson has volunteered her expertise. A member of the USA Track and Field Olympic Medical Staff, she has worked in international competitions in Canada, Spain, England, Japan, Italy, Russia, and at the 2008 Olympics in Beijing. (Courtesy Julie Endreson.)

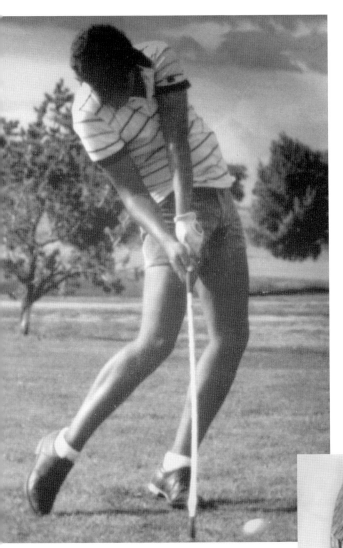

Marty Sanchez (1966–1992)
Sanchez was a native of Santa Fe who, at eight years of age, won first place in the Pee-Wee Division of the Sun County PGA Junior Tournament at the Santa Fe Country Club. After completing his primary education at St. Anne's Parochial school, he went on to Santa Fe High and was a member of the SFHS golf team, winning many tournaments throughout the state. When Sanchez graduated from SFHS in 1984, he was awarded golf scholarships to both New Mexico Junior College and Western New Mexico University, winning championships for both schools. His dream was to become a professional golfer, but in the fall of 1991 he was diagnosed with a cancerous tumor surrounding his vital organs and died in the spring of 1992. Today, the Marty Sanchez Links de Santa Fe Golf Course is named in his honor. (Courtesy Lee Sanchez.)

Charles "Cocoa" Maxwell Jr. (1971–1989)
Maxwell was a gifted athlete and student at Santa Fe High School who committed suicide in 1989. In honor of his memory, his family developed The Charles "Cocoa" Maxwell Jr. Memorial Scholarship Fund, Inc. the year he died. The scholarship is given over a period of four years to student athletes that participate in football or track, the two sports that Maxwell excelled in as a student. A total of four scholarships are awarded each year, one for boy's football and boy's track, and two for girls competing in track. The family's goal is to keep Maxwell's memory alive by both supporting and providing opportunities to the youth of Santa Fe. (Courtesy Charles Maxwell Sr.)

Jannine Cabossel (1953–)
Cabossel moved to Santa Fe 16 years ago and is a professional fine art glassblower at her company, Liquid Light Glass. Cabossel has gardened for more than 30 years and became a Master Gardener in 2010. She teaches classes on vegetable gardening in Santa Fe and is known as "The Tomato Lady'" at the Santa Fe Farmers Market. She also grows giant pumpkins and other giant vegetables and holds many records. In 2010, she broke the New Mexico state record for giant pumpkin. In 2011, she set three new state records with her giant pumpkin at 448 pounds (breaking her previous record), giant zucchini at 62 pounds, and giant green squash at 340 pounds. (Courtesy Jannine Cabossel.)

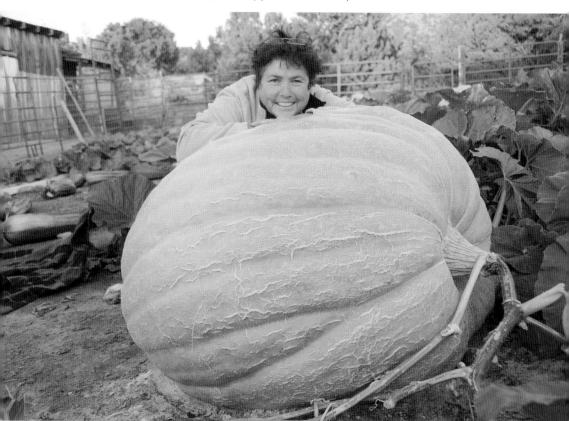

CHAPTER SIX

Business

A business must have a conscience as well as a counting house.

—Montague Burton

Ever since the Camino Real and Santa Fe Trail stopped in Santa Fe, the city has had a plethora of enterprising men and women with the talent, spirit, and staying power that has contributed to the city's vitality. According to historical records, La Fonda Hotel began at its landmark location on the Santa Fe Plaza as the Exchange Hotel in 1821, soon after Capt. William Becknell completed the first successful trading expedition from Missouri to Santa Fe, officially opening the Santa Fe Trail. As the oldest newspaper in the West, the *Santa Fe New Mexican* has provided local, national, and international news coverage since 1849. It was followed by Christus St. Vincent Hospital, which was founded in 1865, and the First National Bank of Santa Fe (1870). Since 1931, the Lensic Theater has provided entertainment to the community. Johnnie's Cash Store started in 1946, and has the distinction of being the oldest family-run grocery store in Santa Fe. The Guadalupe Barber Shop is a father-daughter business that began in 1950. The first Baskin-Robbins franchise came to Santa Fe in 1962 and, today, is the longest continuously operated family-run franchise for the company in the nation. Both Rancho de Chimayo Restaurant and Artesanos Imports began in 1965. The Valdes Business Center on Santa Fe's south side is named for Joseph E. Valdes, the proprietor of Valdes Paint & Glass Company, who was also the mayor of Santa Fe from 1972 to 1976. Guns for Hire is a leather and silverwork business that has been at Santa Fe Village since 1984. Santa Fe's only Spanish Radio Station, KSWV AM 81, Que Suave radio, continues to be the "pulse" of old Santa Fe. Collected Works bookstore has been serving the city's literary needs since 1978. New businesses spring up all the time, including Lan's Vietnamese Cuisine in 2008, and the award-winning Jambo Café, which began serving African and Caribbean cuisine in 2009. Santa Fe's entrepreneurial spirit during these perilous economic times is a testament to the foundation laid by our forefathers, who ventured forth into the unknown.

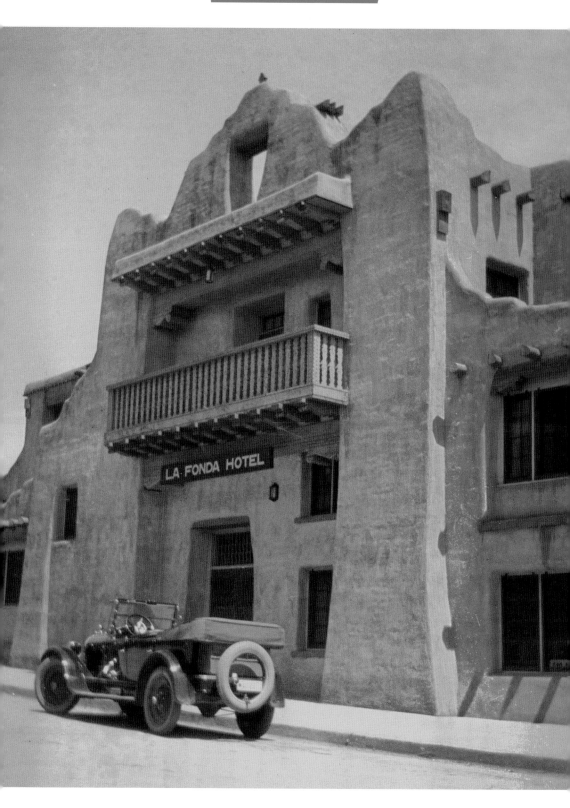

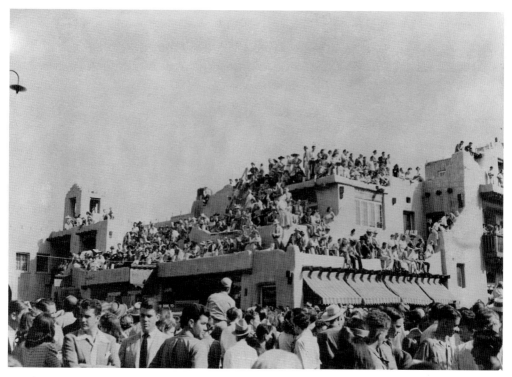

La Fonda Hotel during the Fiesta de Santa Fe
People crowd on the roof of La Fonda Hotel in the 1950s during Fiesta de Santa Fe. (Courtesy Palace of the Governors Photo Archives [NMHM/DCA], No. 2007.20.678.)

La Fonda Hotel (OPPOSITE PAGE)
According to historical records, La Fonda Hotel began at its landmark location on the Santa Fe Plaza as the Exchange Hotel, soon after Capt. William Becknell completed the first successful trading expedition from Missouri to Santa Fe, officially opening the Santa Fe Trail. In 1833, Mary Donoho, the first Anglo American woman, traveled along the trail from Missouri with her husband, William, and operated a hotel for seven years. During the 19th century, the hotel went through various incarnations as the Exchange Hotel, the Santa Fe House, US Hotel, and finally La Fonda. The fonda (inn) by any name was the preferred place of lodging for trappers, soldiers, gold-miners, gamblers, and politicians. Today, this landmark hotel continues to define the ambiance of old Santa Fe. (Courtesy Maude P. Danburg and Palace of the Governors [NMHM/DCA], No. 094626.)

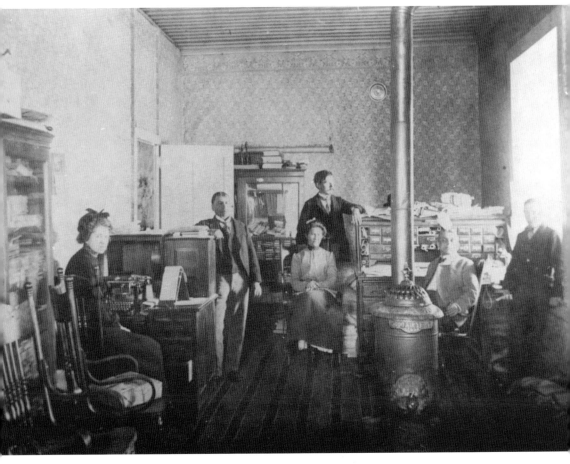

Santa Fe New Mexican
This 1899 photograph of the editorial office and staff is one of the earliest photographs on record of the oldest newspaper in the West. In its 164-year history, the paper has had several different publishers and has undergone many successful transformations, most recently, the advent of digital media. Today, the *New Mexican* continues to provide the best local news coverage in the state's capital, 365 days a year. (Courtesy *Santa Fe New Mexican*, No. 15275.)

Christus St. Vincent Hospital

In 1884, four Sisters of Charity came to Santa Fe from Cincinnati, traveling by boat, train, and stagecoach to open St. Vincent Hospital. A year later, in 1865, the Sisters of Charity arrived from France at Galveston Island in Texas and started the first Christus Hospital. In 1883, St. Vincent Sanatorium was built, and three years later was destroyed by fire. In 1920, a second sanatorium opened that had electricity, steam heat, and a laboratory. A new hospital was built next to the sanatorium in 1950 and, by 1977, the hospital moved to its current location on St. Michael's Drive. St. Vincent's Marion Hall is pictured in 1906. (Courtesy Christus St. Vincent Hospital.)

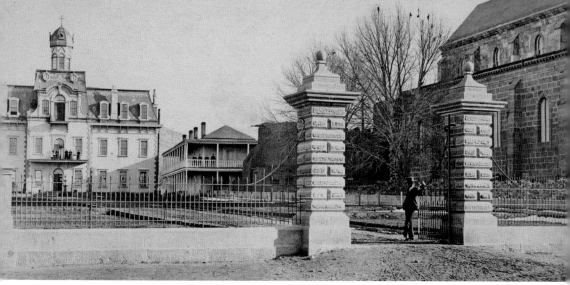

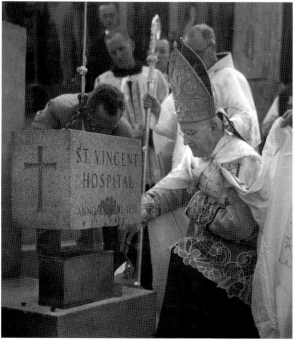

Christus St. Vincent Hospital
In 1951, Archbishop Vincent Edward Byrne blesses the newly erected cornerstone for St. Vincent Hospital. (Courtesy Tyler Dingee and the Palace of the Governors Photo Archives, NMHM/DCA 067793.)

83

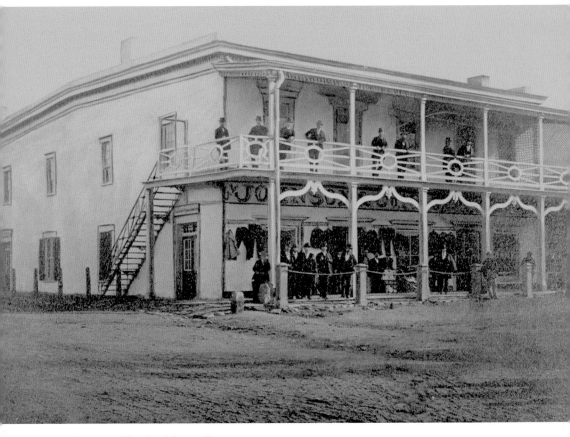

First National Bank of Santa Fe
First National Bank is the oldest bank in the Southwest. It was founded 45 years before New Mexico became a state. During its early history, the independently owned commercial bank and trust company primarily served the ranching and mining communities. It was one of the few banks in the region to survive the Great Depression. During World War II, the bank was the repository of funds for the government's Los Alamos operations. The bank is pictured here in 1872. (Courtesy First National Bank of Santa Fe.)

Lensic Theater (OPPOSITE PAGE)
The Lensic Theater was built by Nathan Salmon and E. John Greer in 1931. During much of the 20th century, it was a movie theater. In 2000, it underwent a major renovation, and in 2001, it reopened as a nonprofit performing arts center that works to foster performance, educational, and community programs. It provides world-class entertainment, subsidizes local arts, and provides free programs to schoolchildren. The Lensic Theater is seen here in 1934. (Courtesy T. Harmon Parkhurst and Palace of the Governors [NMHM/DCA], No. 050969.)

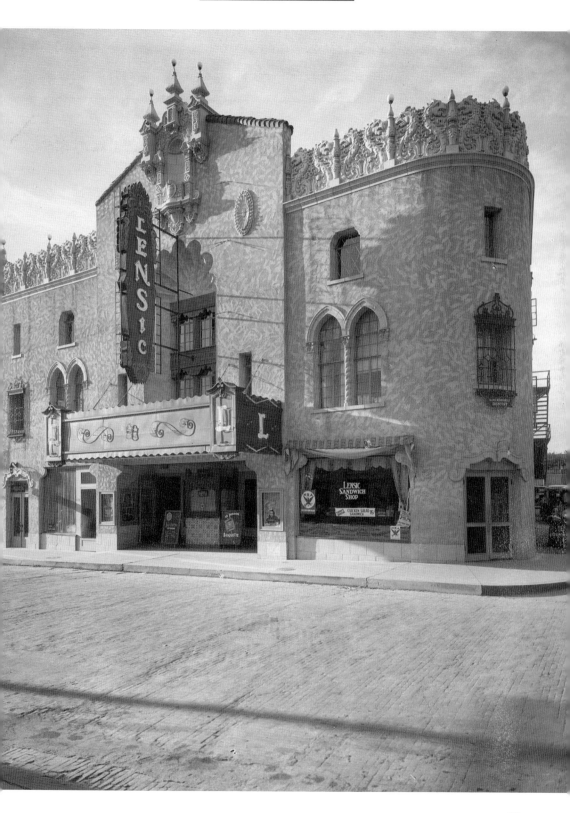

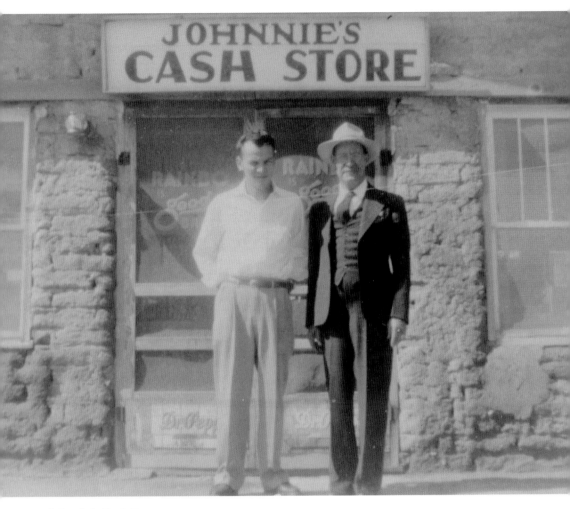

Johnnie's Cash Store

Johnnie Armijo (1929–) is the proprietor of the oldest family-run grocery store in Santa Fe. Located at 420 Camino Don Miguel, the store was opened in 1946 by his father, Orlando Armijo (right). Since then, seven generations of families have traded with the Armijo family. Situated on a side street off of posh Canyon Road, Johnnie's Cash Store has been written about in the Washington Post Magazine. The article stated that the quaint little store was a living museum, with its antique freezers still humming along, where you can buy a soda, a pack of gum, or laundry detergent. Best of all, patrons in search of a quick, affordable lunch can buy warm, fresh tamales. Johnnie (left) and Orlando Armijo are shown in 1946. (Courtesy Johnnie Armijo.)

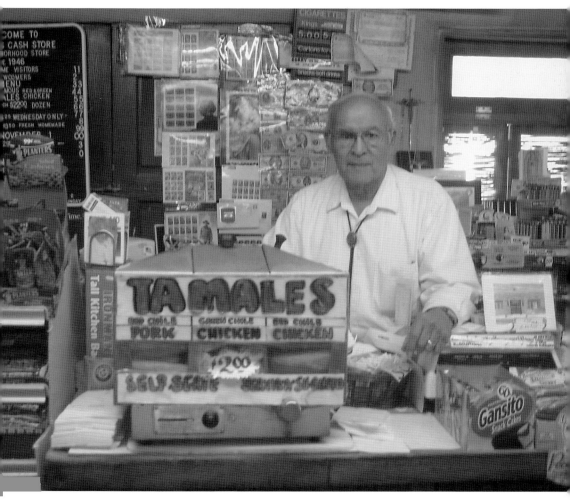

Johnnie Armijo

In the old days, Johnnie's Cash Store carried boots, radios, cameras, and leather jackets along with fresh meat, produce, and canned goods. Monday through Saturday, you can find 84-year-old Armijo working behind the counter. He is shown here in the store today. (Courtesy Ana Pacheco.)

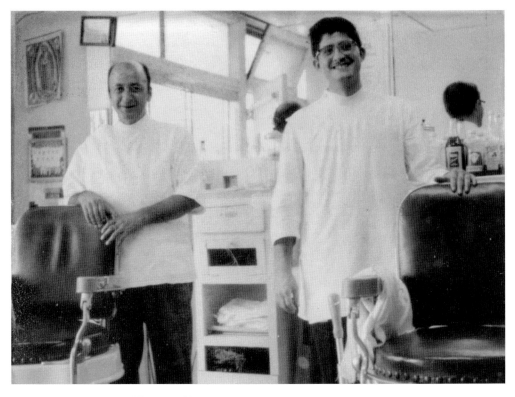

Guadalupe Barber and Beauty Shop

Arthur Garcia (1938–) learned the art of barbering from his father, Henry Garcia, and in 1950, went to work for him at their first location on De Vargas Street. In 1960, the business moved to Guadalupe Street, and the business has been at its current location on Aztec Street since 1979. Henry Garcia died in 1983, and in 1985, Garcia's youngest daughter joined the business. Michelle Lahargoue (1966–) has helped grow the business from just a barbershop to a full-fledged beauty salon. While Lahargoue cuts and colors women's hair, her father continues to provide traditional haircuts for men. Shown above are Henry (left) and Arthur Garcia in 1962. Michelle Lahargouge and Arthur Garcia are pictured below in 2012. (Courtesy Arthur Garcia and Ana Pacheco.)

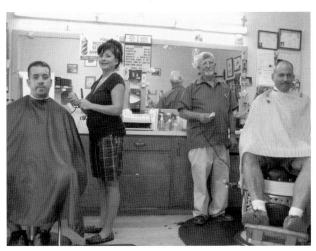

Ortiz Grocery Store

Don Ortiz (1934–) was first introduced to business as a young boy when he helped out at his father's grocery store. Frank Ortiz was the proprietor of the Ortiz grocery store from the 1940s through the 1960s. From 1948 through 1952, he was also the mayor of Santa Fe. After his father closed the store, Don Ortiz was offered a job in 1964 as a stockbroker for Quinn & Company. That led to a banking career, and in 1975, he became the chairman of United Southwest National Bank. When the bank was sold in 1981, Ortiz began Fidelity Realty and the Don Juan Gallery & Gift shop at Sena Plaza. Now retired, Ortiz (right) will never forget the sage advice he received from his father that gave him the drive and determination to succeed in business: "Santa Fe is a tough town. If you can make a million dollars here you could make $100 million someplace else." Above, the Ortiz Grocery Store is shown with the Anheuser-Busch Clydesdale horses in 1938. (Courtesy Mike Ortiz and Ana Pacheco.)

Artesanos Import Company

Polo Gomez (1927–) moved to Santa Fe from Mexico City in 1950. His first job was as a gardener and caring for the dogs of A.J. Taylor, who owned the Old Mexico Shop. Later, he went to work at the shop, where for the next 11 years he swept floors. It was during that time that he absorbed the workings of a retail business. With the encouragement of Stanley Marcus of the Nieman Marcus department store, whom Gomez had done work for at his Santa Fe home, he decided to strike out on his own by opening his first store, Artesanos Imports, in Española in 1955. In 1965, Gomez moved the business to Santa Fe and, with the help of his family, has enjoyed 48 years of business. (Courtesy Ana Pacheco.)

Baskin-Robbins

Tony "Cookie" Quintana (1927–2012) opened Santa Fe's first Baskin-Robbins franchise in 1962. It was the company's 100th franchise, and today it is its oldest continuously operated family-run franchise. Quintana received his nickname, "Cookie," as a student because of his sweet tooth. During his years at Santa Fe High School, he was an athlete, and through his career, he has supported athletes during their school years by providing them with jobs scooping ice cream. Quintana is pictured here as a student at Santa Fe High School. (Courtesy of the Quintana family.)

Rancho de Chimayo

Since 1965, Florence Poulin Jaramillo (1930–) has been the proprietor of the Rancho de Chimayo restaurant. She moved to New Mexico from Connecticut 48 years ago with her former husband, Arturo Jaramillo, and started the restaurant in the home of his grandparents. Today, Rancho de Chimayo has provided employment for hundreds of people in northern New Mexico. (Courtesy Ana Pacheco.)

Old Santa Fe Trail Religious Shop

In 1978, Connie Hernandez (1925–) opened her store that has provided the community with religious articles, as well as items for the sacraments of baptism, confirmation, and First Holy Communion in the location that was formerly the family home where she was born. (Courtesy Ana Pacheco.)

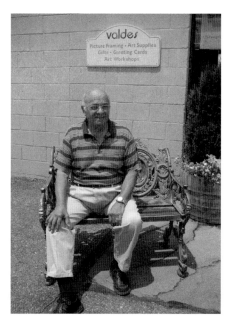

**Valdes Paint &
Glass Company**
Joseph E. Valdes (1930–) has been the proprietor of Valdes Paint & Glass since 1972. In 1979, Valdes Picture Frames & Art Supplies opened next door, providing art workshops in the summer and fall by nationally acclaimed art instructors. Valdes was the mayor of Santa Fe from 1972 through 1976, and during that time, he worked hard to promote economic growth. The Valdes Industrial Park, named for him, was one of the projects that he helped to create. Today, it fosters many business enterprises. (Courtesy Ana Pacheco.)

Collected Works Bookstore & Coffeehouse
Just a short walk from the plaza, Collected Works Bookstore & Coffeehouse has been serving the literary needs of Santa Fe since 1978. In 1996, Dorothy Massey (1938–) and her daughter, Mary Wolf (1968–), became the third owners of the store. The bookstore relocated to its current location, at the corner of Water and Galisteo Streets, in 2009. The expanded 5,000-square-foot space boasts a full coffee café, an outside summer patio, and a stage for author events. Collected Works hosts many local events beyond its own literary offerings and has become a true community center. (Courtesy Mary Wolf.)

Guns for Hire
R. "Bear" Campbell (1942–) has operated his leather and silverwork business since 1985 at the Santa Fe Village mall. A native of Colorado, Campbell lived on the Laguna Reservation in western New Mexico with his girlfriend, Jane Paquin, for three years prior to moving to Santa Fe. He came up with the name of his business from his previous career as an entertainer and Western stuntman. (Courtesy Linda Carfagno.)

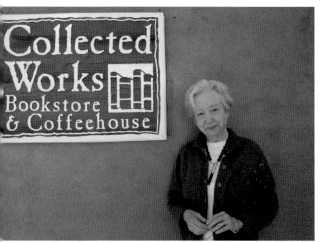

Lan's Vietnamese Cuisine

Lan Tran (1967–) was born during the height of the Vietnam War, in Hoi An in central Vietnam. It was a difficult time for her parents, who were unable able to care for all of their 10 children. So Tran and several of her sisters were sent to the central highlands to be raised by her grandmother, after their grandfather was killed by the Viet Cong for being suspected of conspiring with the Americans. Her grandmother, Nhan Tran, lived very simply, in a bamboo-frame, open-air house with a rice grass roof. It was during these years that her grandmother taught Tran and her sisters how to cook, gather food, and raise children and animals. When she moved to Santa Fe in 1997, Tran began selling Vietnamese lunches to businesses around town. The enthusiastic response she received gave her the courage to open a small luncheonette at the Santa Fe Village. By 2008, she outgrew that location and now operates a full-service restaurant at College Plaza. This year, Tran plans on visiting her 98-year-old grandmother and the home where she grew up and learned the secrets of Vietnamese cuisine. (Courtesy Clint Demmon.)

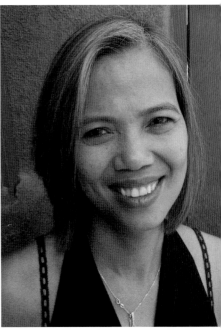

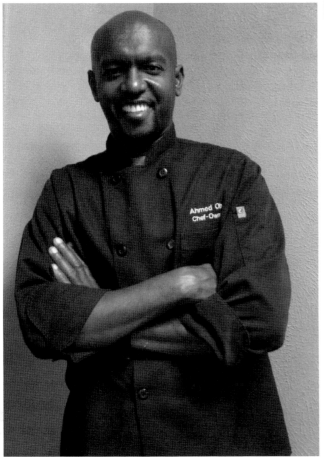

Jambo Café

When Ahmed Obo (1972–) visited Santa Fe a few years ago, he fell in love with the citizens, who reminded him of those in his hometown in Africa. So, in 2009, he decided to make Santa Fe his newly adopted home and opened the Jambo Café. Almost immediately, Santa Fe fell in love with the exotic flavors of Obo's birthplace of Lamu, an island off the coast of Kenya. As a young boy, Obo learned from his mother, Halima Ziwa, how to meld distinct Arabic and Indian influences with a dab of Swahili. The Jambo Café has won the annual Santa Fe Souper Bowl contest for Obo's different soups for the last three years. (Courtesy Ana Pacheco.)

Que Suave Radio (KSWV AM-81)

Since the 1960s, George Gonzales (1938–) and his family have been involved in serving the community of Santa Fe and northern New Mexico. Back then, Gonzales and his wife, Celine Vigil (1939–), owned two radio stations, KDCE and KBSO, in Española, New Mexico. When they sold those stations, they launched Que Suave Radio, Santa Fe's only Spanish-language station. The station takes pride in being a community broadcasting company devoted to high school sports, city, county, and state issues, as well as education and health programming. In 2007, the family launched the monthly publication Santa Fe Hometown News. With the help of their four sons, George (far right) and Celine Gonzales have successfully built a media business known to many as "the pulse" of old Santa Fe. Pictured from left to right are (first row) Celine Gonzales, Javier Gonzales, and George Gonzales; (second row) Patrick Gonzales, Stephen Gonzales, and Anthony Gonzales. (Courtesy George and Celine Gonzales.)

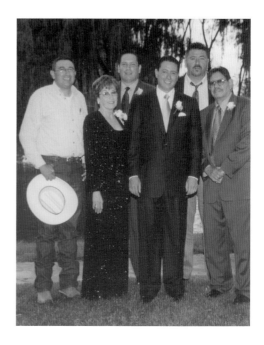

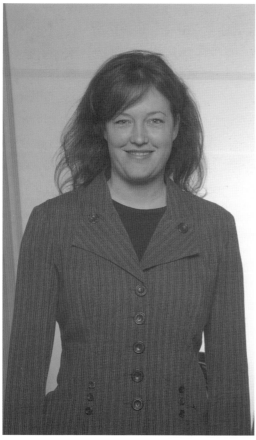

Xynergy, Inc.

Jennifer Martin (1970–) was on the ground floor of digital marketing at a time when few people had even heard of the Internet. In 1994, she launched Xynergy, Inc., a full-service company providing complete site development, hosting, and marketing solutions. Today, Martin's company has a local and international client base and has created close to 1,000 websites. Xynergy is the second-oldest Web development firm in New Mexico. Each year, the company donates website expertise to local organizations, including the New Mexico Special Olympics, Theater Grottesco, Girls Inc. of Santa Fe, and many other nonprofit organizations. (Courtesy Jennifer Martin.)

CHAPTER SEVEN

Military Service

War does not determine who is right—
only who is left.

—Anonymous

Fort Marcy was built in 1846 to support and protect traders along the Santa Fe Trail during the Mexican-American War and the California Gold Rush of 1849. Brig. Gen. Stephen Watts Kearny traveled along the Santa Fe Trail with his troops, taking control of New Mexico, which was the start of the American occupation. Commonly referred to as the "Gettysburg of the West," the Battle of Glorieta, 22 miles from Santa Fe, marked the turning point for the Civil War in New Mexico, where close to 200 Confederate soldiers lost their lives. Santa Fe native Hilario A. Delgado was a World War I veteran and charter member of VFW Post 2951 in 1934. On June 6, 1944, Carl Tsosie and Manuel Rodriguez participated in the Battle of Normandy, the largest seaborne insurgency during World War II. Vicente Ojinaga is one of the last survivors of the Bataan Death March of World War II, and Col. George R. Hawthorne took part in the Manhattan Project during World War II. Maj. Gen. Franklin Miles is a member of the Hall of Fame at both the New Mexico Military Institute and the Officer Candidates School at Fort Benning, Georgia. Mary Louise Graw and Stella Lavadie were among the more than 150,000 women who enlisted in the Women's Army Corps during World War II, and Cholene Espinoza was the second woman to fly the U-2 reconnaissance aircraft in the US Air Force. Rosemary Morales-Vargas, a US Marine who served in the first Gulf War, is currently serving as the first female commander for the Santa Fe VFW Post 2951. Sgt. Paul A. Duran, also of Santa Fe, was a scout sniper in the 1st Battalion and 5th Marine Regiment during three tours in the Middle East. And Santa Fe native Army Sfc. Leroy A. Petry was awarded the Medal of Honor in 2011 for saving the lives of several soldiers in his regiment in a 2008 firefight in Afghanistan.

Carload of Governors, Fort Marcy Hill, Santa Fe, New Mexico, in 1912
From left to right are Herbert Hagerman, Miguel A. Otero (driver), William T. Thornton, and L. Bradford Prince, on the occasion of the reading of the Declaration of Independence on July 4, 1912. (Courtesy Aaron B. Craycraft and the Palace of Governors Photo Archives, NMHM/DCA 140378.)

Fort Marcy
Fort Marcy was built by the US Army during a time of converging historical events, including, the ongoing conflict between Native Americans and traders along the Santa Fe Trail, increased traffic on the trail during the Mexican-American War of 1846, and the California Gold Rush of 1849. Today, the former military grounds are home to the Fort Marcy sports facility and baseball field. The burning of Zozobra is held at Fort Marcy as the kickoff to the annual Santa Fe Fiesta. (Courtesy Palace of the Governors [NMHM/DCA], No. 1727.)

Brig. Gen. Stephen Watts Kearny (1794–1848)
Kearny arrived in Santa Fe in 1846 during the Mexican-American War. With military precision, he ordered approximately 2,500 troops to take control of New Mexico and surrounding territories. He then served as New Mexico's military governor from 1846 to 1847. Kearney spent his career in the military and fought his first battle in the War of 1823. He died in 1848 of yellow fever at the home of Maj. Meriwether Lewis Clark, son of William Clark of the Lewis and Clark expedition, and stepbrother of his wife, Mary Radford. Kearny Elementary in Santa Fe is named for him. (Courtesy Palace of the Governors [NMHM/DCA], No. 009939.)

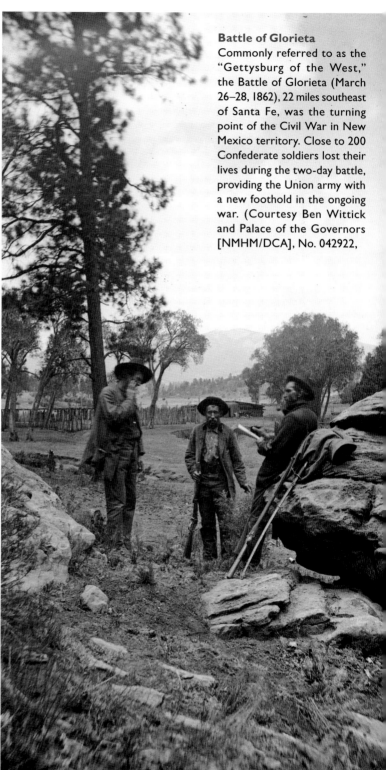

Battle of Glorieta
Commonly referred to as the "Gettysburg of the West," the Battle of Glorieta (March 26–28, 1862), 22 miles southeast of Santa Fe, was the turning point of the Civil War in New Mexico territory. Close to 200 Confederate soldiers lost their lives during the two-day battle, providing the Union army with a new foothold in the ongoing war. (Courtesy Ben Wittick and Palace of the Governors [NMHM/DCA], No. 042922,

Hilario A. Delgado
(1892–1955)

Delgado, the father of future mayor Larry Delgado, was one of 40 World War I veterans who, on July 5, 1934, established Santa Fe's only VFW, Post 2951. Members of the charter also included Sen. Bronson Cutting, who was a captain in the Army and the former owner of the Santa Fe New Mexican. Although the first members came from diverse backgrounds, the one thing they all shared was patriotism, a thread that has run through all of its members for the last 79 years. (Courtesy Larry Delgado.)

here's the real thing

Coke

Col. George R. Hawthorne (1918–)

Hawthorne was one of many military personnel to work on the Manhattan Project during World War II. As an officer in the US Army Corps of Engineers for 38 years, he contributed much to his country as a military engineer, as well as during his years as a civil engineer, helping to build New Mexico's infrastructure. Hawthorne is known around Santa Fe as the "Walking Encyclopedia" on World War II. He's never without his trademark World War II jacket and long, white beard. His portrait is on permanent display at the De Vargas Mall. (Courtesy Ana Pacheco.)

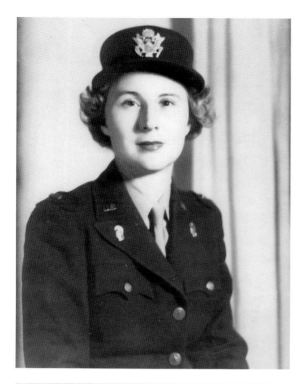

Mary Louise Graw (1914–)
Graw was one of more than 150,000 women who enlisted in the Women's Army Corps (WAC) during World War II. As a WAC second lieutenant recruiting officer, she regularly traveled to her regiment's headquarters in Santa Fe from her post in Clovis, New Mexico. She met her husband, Lt. John Graw, in 1943 in Santa Fe. When the couple married and she became pregnant with her first child, she was required to leave the military. (Courtesy Mary Louise Graw.)

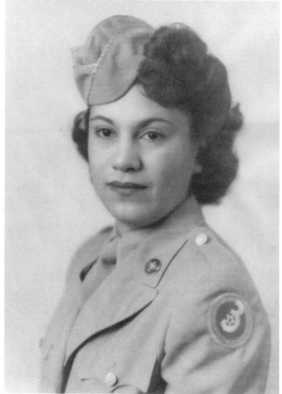

Stella Lavadie (1921–)
Lavadie enlisted in the WAC after the attack on Pearl Harbor, because she wanted to do her part during World War II. Although she was never sent overseas, Lavadie was stationed at different bases around the country, where she worked in supply headquarters keeping track of inventory. In 2010, she took part in the tribute "Women in the Military" at Kirtland Air Force Base in Albuquerque. She is a lifetime member of VFW Post 2951 in Santa Fe and is also a member of the Santa Fe Fiesta Council and the Catholic Daughters of America. Lavadie is especially proud that two of her sons are military veterans. (Courtesy Stella Lavadie.)

Vincente Ojinaga (1918–)

Ojinaga is one of Santa Fe's last surviving prisoners of the Bataan Death March. On April 9, 1942, Ojinaga's entire platoon of the 200th Coast Artillery, which consisted of 1,800 New Mexicans, was captured. The next day, they joined 75,000 soldiers in the arduous 60-mile march to a prison camp in Luzon in the Philippines. The walk claimed the lives of 16,950 American and Filipino soldiers. Above, Ojinaga is pictured with his photograph of the 200th Coast Artillery. (Above, courtesy Ana Pacheco; below, courtesy Palace of the Governors, NMHM/DCA, No. HP.2007.20.331.)

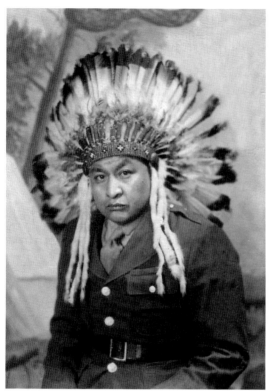

Carl Tsosie (1917–2010)

Tsosie was born on the Navajo reservation in Salina Springs, Arizona. He graduated from the Santa Fe Indian School in 1938, and served in the Army during World War II. He participated in the invasion at Normandy, where he received a Purple Heart. After the war, Tsosie taught woodworking at his alma mater and was known for his craftsmanship in the many homes that he helped build for the Casa Alegre and Casa Solana developments in Santa Fe. (Courtesy Connie Tsosie Gaussoin.)

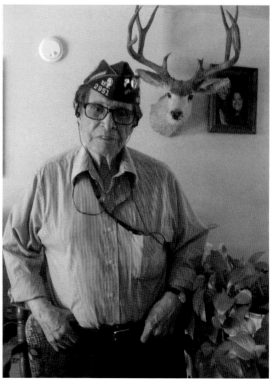

Manuel Rodriguez (1923–)

When Rodriguez was in the 11th grade at St. Michael's High School, he enlisted in the Army. A year later, on June 6, 1944, he participated in the Battle of Normandy, the largest seaborne insurgency during World War II. He also fought in the Battle of the Bulge toward the end of the war and helped liberate Nazi concentration camps in northern Germany. Rodriguez received the Bronze and Silver Medals for valor and bravery for his service during the war. (Courtesy Ana Pacheco.)

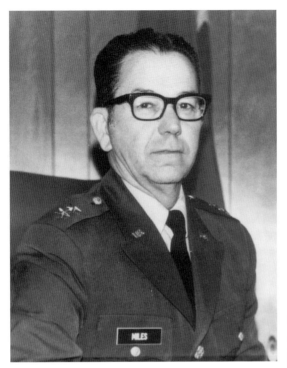

Franklin E. Miles (1923–)

The son of John E. Miles, who served as governor of New Mexico from 1939 to 1942, Franklin E. Miles graduated from the New Mexico Military Institute in 1944. The following year, he was sent to the Philippines, where he served as a second lieutenant during World War II. Upon his return from the war, he served with the New Mexico National Guard during both the Korean War and Vietnam War. He retired from the guard as a major general in 1984. Miles is a member of the Hall of Fame at both the New Mexico Military Institute and the Officer Candidates School at Fort Benning, Georgia. (Courtesy Franklin E. Miles.)

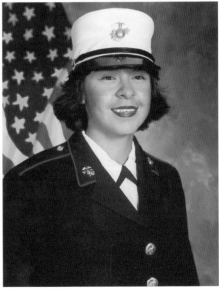

Rosemary Morales-Vargas (1969–)

Vargas, who was born in Santa Fe, is currently serving as the first female commander for the Santa Fe VFW Post 2951. She served in the Marines during the first Gulf War as a diesel mechanic in support of ground warfare. She met her husband, Joseph Vargas, who was also a Marine, 15 miles from the Kuwaiti border. They have three children; their oldest son is an officer and a marine engineer in the Navy. (Courtesy Rosemary Morales-Vargas.)

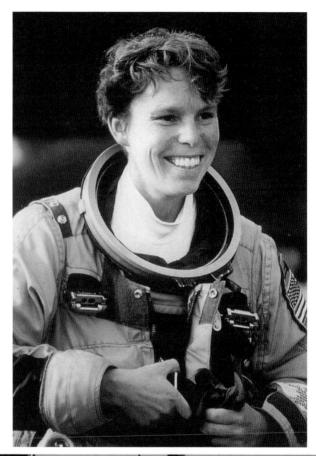

Cholene Espinoza (1956–)
Espinoza was born in Santa Fe County in the community of Española. She graduated from the US Air Force Academy in 1987 and was selected to be a jet instructor pilot in 1988, training pilots from all over the world. She was the second woman to fly the U-2 reconnaissance aircraft in the US Air Force. She is a military correspondent for Talk Radio News Service and was an embedded journalist with the US Marine Corps, 1st Tank Battalion during the Iraq War. She has also reported from Syria, Gaza, the West Bank, Jerusalem, Jordan, and Kuwait. Throughout her career, she has won numerous awards, including Squadron Officer of the Year in 1990 and the Lance P. Sijan US Air Force Leadership Award in 1991. Espinoza is currently in her second year of medical school at St. George's University in Grenada, West Indies. (Courtesy Cholene Espinoza.)

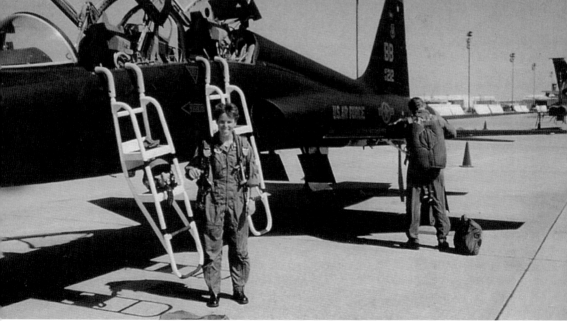

Leroy Arthur Petry (1979–)
Petry, a Santa Fe native, was awarded the Medal of Honor on July 12, 2011. In a White House ceremony presided over by Pres. Barack Obama, the Army sergeant, first class was nominated for his bravery in a firefight in Afghanistan on May 26, 2008, in which he lost his lower right arm in a grenade explosion helping to save members in his platoon. He served for 28 months in eight deployments to Iraq and Afghanistan. (Courtesy *Santa Fe New Mexican.*)

Paul A. Duran (1986–)
Duran grew up in Santa Fe, where he attended Capital High and Santa Fe High School. In 2003, he joined the US Marine Corps and served three tours in the Middle East. Sergeant Duran was a scout sniper in the 1st Battalion and 5th Marine Regiment. When he returned from service in 2008, he received his associate's degree from Santa Fe Community College. He currently lives in Albuquerque. (Courtesy Paul A. Duran.)

CHAPTER EIGHT

Public Service

Just don't give up on doing what you really want to do.
Where there is love and inspiration, I don't think you can go wrong.

—Ella Fitzgerald

A champion of women's rights, Concha Ortiz y Pino de Kleven served under the leadership of five US presidents, who appointed her to national boards that fought for the handicapped, the humanities, and the arts. When Betty Boyce Stewart died in 1994, she left a generous bequest to the local animal shelter, the facility that is now named in her honor. Connie Gaussion Tsosie is a former radio host and has served on numerous boards advocating for Native Americans, youth, culture, and the arts, and Mary Lou Cook started Santa Fe's Living Treasures program in 1984 as a way to honor the community's elder population. Mary Cabot Wheelwright provided the financial support to start the Wheelwright Museum of the American Indian in Santa Fe. At 104 years of age, Marvin Langham was New Mexico's oldest active member of the Lion's Club. Carol Jean Vigil was the first Native American judge in the nation, and Rabbi Leonard A. Hellman founded a bridge center in his name and established a scholarship for young people interested in playing bridge. Louis Zucal was a family doctor in Santa Fe for over four decades and was also the physician for the New Mexico State Penitentiary during the riot of 1980. Elspeth Bobbs, a master gardener, is also one of Santa Fe's leading philanthropists. Stewart L. Udall, the former secretary of the interior for the Kennedy and Johnson administrations, was an environmentalist and writer. Carl O. Walker was a member of Roosevelt's "Tree Army" during the Great Depression. For the past 30 years, Abdallah Samuel Adelo has been a Spanish-language interpreter for the judicial system. Angela "Spence" Pacheco was the first woman elected as district attorney in northern New Mexico, and Santa Fe native Gilbert L. Delgado was the nation's first Hispanic superintendent of the School for the Deaf. Marjorie Muth spearheaded some of the first programs in Santa Fe to care for retarded children, and Alfonso Alderete spent 50 years tending bar in Santa Fe. For the last 27 years, Max Randolph has worked with the bereaved at Berardinelli Family Funeral Home. Dolores Valdez de Pong preserved history and culture as a teacher in the public school system for 37 years, and Kimi Ginoza Green has spent 24 years working in philanthropy and community development.

George Cowan (1920–2012)

Cowan came to New Mexico during World War II and worked with the Manhattan Project as a chemist to build the first atomic bomb. His scientific work also included the testing of the first hydrogen bomb. Cowan was the treasurer of the Santa Fe Opera in 1953, while it was being formed. In 1963, he founded the Los Alamos National bank, and for three decades was the bank's chairman. In 1984, Cowan was one of the founders of the Santa Fe Institute. The scientific research center, comprised of individuals from both the public and private sectors, utilizes a cross section of disciplines, from physics to the humanities, to find solutions to address an array of subjects like evolution and urban sustainability. (Courtesy *Santa Fe New Mexican.*)

Mike Cerletti (1939–2012)

Cerletti served two terms as the New Mexico secretary of tourism. He is credited with enhancing the state's reputation as a major tourist destination. Under his direction, New Mexico participated in four annual Tournament of Roses parades, providing the state with national media coverage. In 2010, Cerletti was named State Tourism Director of the Year by the National Council of State Tourism Directors. When Cerletti moved to Santa Fe in 1974, he became a managing partner at some of Santa Fe's leading hotels. He was also a board member of many nonprofit organizations, including the Santa Fe Fiesta Foundation, which supports the religious festivities during the annual fiesta. (Courtesy Herb Lotz.)

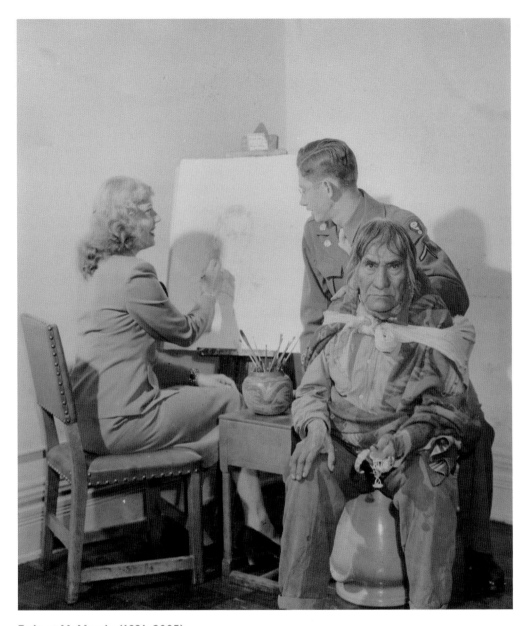

Robert H. Martin (1921–2005)
After World War II, in 1946, the Army transferred Martin to work as the photographer for Los Alamos National Laboratory. For the next 33 years, he documented all aspects of work done at the lab. When he was not working on government-classified assignments, he captured the essence of Santa Fe on film. Today, 60 years of Martin's photography can be found in museums throughout the state. His subjects ranged from community events, to leading writers, artists, and other members of Santa Fe's intelligentsia. Martin was never without a camera, and when he died in 2005, he was buried with it. He is pictured above in a self portrait with Ramor Baumann Ortiz and Jose Calabasa. (Courtesy Robert H. Martin.)

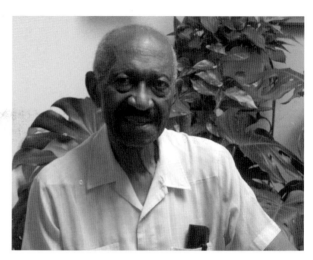

Jon Hendry (1962–)

Hendry is currently the president of the New Mexico Federation of Labor and Business Agents for IATSE Local 480 (Film Technicians Union). Since he moved to Santa Fe in 1986, Hendry has promoted the city through the arts, particularly film and television. He is a former marketing director for the state and a long-term member of Santa Fe's Occupancy Tax Advisory Board. (Courtesy Ana Pacheco.)

Alfonso Alderete (1924–2012)

Alderete was one of 11 children born to Francisco and Eusevia Alderete in Matanza, Cuba. He came to the United States in 1947 under the sponsorship of the Johns family of northern New Mexico. By 1950, he had his first job, bartending at La Fonda, which turned into a career that spanned 50 years and included many of Santa Fe's most popular watering holes. When he finally retired in 2003 from the Palace Restaurant, a huge party was held for him. In attendance were the powerful, the prosperous, and, of course, the partiers. (Courtesy Ana Pacheco.)

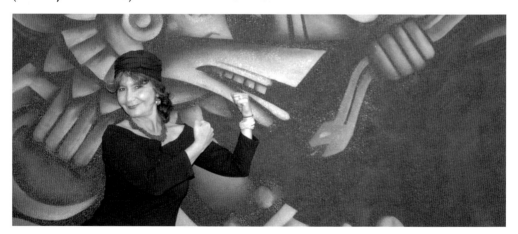

Ana Gallegos y Reinhardt (1957–)

Gallegos y Reinhardt was born into the world of Santa Fe politics. As a child, she watched her father, the former senator Ralph Sabu Gallegos, as he worked to create social change. It was his inspiration and her inner child that inspired much of her career working with youth at some of Santa Fe's most creative organizations and her current position as the executive director of Warehouse 21, Santa Fe's Teen Arts Center. She was on the ground floor of the founding of the center at the Santa Fe Railyard, where she worked to build a long-term home for the organization. A registered nurse by trade, she has received numerous awards throughout her career, including the Governor's Award by the New Mexico Status of Women in 2009. (Courtesy Jennifer Esperanza.)

María Concepción "Concha" Ortiz y Pino de Kleven (1910–2006)
A champion of women's rights, Concha served under five US presidential administrations, Kennedy, Johnson, Nixon, Ford, and Carter, each of which appointed her to national boards that fought for the handicapped, the humanities, and the arts. In the 1940s, she became the "boss lady" of her family's 100,000-acre Agua Verde Ranch, which, at the time, was one of the biggest ranching commercial enterprises in the state. Her ancestors were part of New Mexico's founding families. (Courtesy Robert H. Martin.)

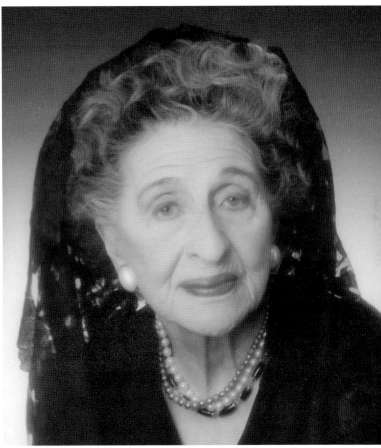

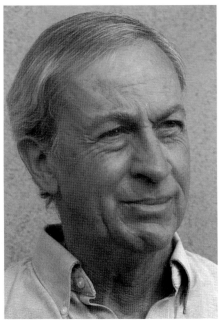

Michael Romero Taylor (1951–)
Romero Taylor is a descendent of the Romero family, one of the many Hispanic families that had an important role in trading along the Santa Fe Trail in the 1800s. His great-great-grandfather, Miguel Romero, was one of the founding members of the city of Las Vegas, New Mexico. Romeroville, just south of Las Vegas, was named for his family. During his 38-year career, Romero Taylor has devoted his life to historic preservation, first, as a New Mexico State Historic Preservation officer and, later, as the deputy director of New Mexico State Monuments. Romero Taylor currently works as a National Park Service cultural resource specialist for nine congressionally designated historic trails in the United States, including Route 66 and the Camino Real, two of New Mexico's most historic roads. (Courtesy Michael Romero Taylor.)

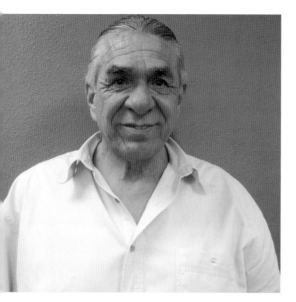

Sam Leyba (1950–)
Leyba, who was born in Santa Fe, has been involved with community organizations since 1965, when he became a member of Young Citizens for Action. An advocate for social justice, he has been the cofounder of organizations like Escuela Y Colegio Tonantzin and La Clinica de la Gente. In 1974, he cofounded Barrio Arts, Inc., which provided a venue for teenagers to express themselves artistically, and in 1995, he cofounded Santa Fe's National Dance Institute. As an artist, he has created over 80 local, state, and national public art murals and mosaics. Since 1974, he has been a member of the band Lumbre del Sol. Leyba has received numerous awards for his work and currently works as an intake counselor at the Esperanza Family Shelter. (Courtesy Ana Pacheco.)

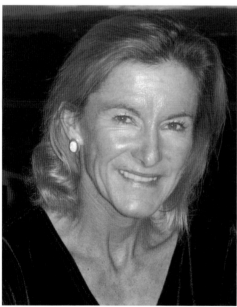

Pamela Roy (1960–)
Roy, a Santa Fe native, is the executive director of Farm to Table, a nonprofit organization that works to promote locally based agriculture. She is also the director of the New Mexico Food and Agriculture Policy Council, which works on state and federal policy advocating for food system issues including health, nutrition, hunger, family-sized farms, and ranch policies. During the last 20 years of her organizational development and farmers' market experience, she has worked internationally and with local organizations like the Tribal Farmers' Market development and initiated regional food policy. She is the former president of the North American Farmers' Direct Marketing Association. (Courtesy Pamela Roy.)

Betty Boyce Stewart (1925–1994) (OPPOSITE PAGE)
Stewart was born in Dalhart, Texas, and grew up on ranches in Texas and New Mexico. She was the owner of the Stewart Construction Company, which built traditional New Mexican homes for a clientele of discerning taste. The homes often included antique doors, vigas, and moldings salvaged from old adobe buildings. In addition to gaining a reputation for her expertise as a home builder, she was known around town for her signature cowboy boots and her love of animals. When Stewart died, she left a generous bequest to the local animal shelter. (Courtesy Santa Fe Animal Shelter.)

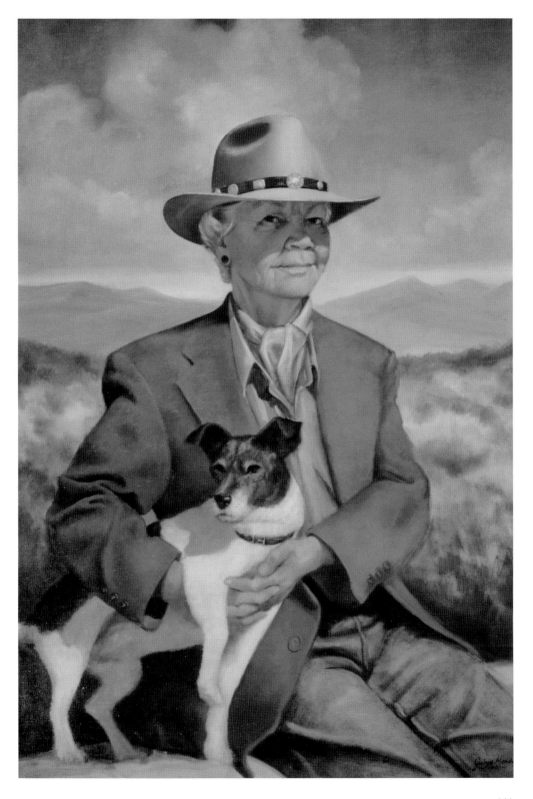

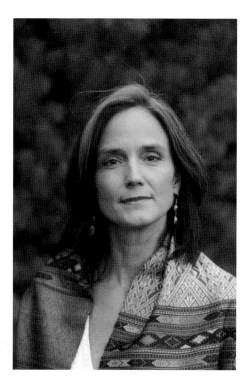

Gay Dillingham (1965–)
Dillingham moved to Santa Fe in 1987. She is the cofounder of Earthstone International and Growstone, two New Mexico environmental IP companies that manufacture recycled glass, nontoxic cleaning technologies, and agricultural products. Dillingham's public service includes eight years on the New Mexico Environmental Improvement Board, through 2010. She currently serves on the boards of the Santa Fe Community College, Bioneers, the World Security Institute, and she is an honorary board member for the Coalition for Quality Children's Media. Dillingham also owns the production company CNS Communications and is an award-winning producer/director. (Courtesy Gay Dillingham.)

Sadaf Rassoul Cameron (1979–)
Rassoul Sadaf is the director of the Kindle Project, the organization she cofounded in 2008 in Santa Fe. The project aims to foster the work of artists, bringing attention to their work through an array of both media and digital outlets. Rassoul Cameron's community work includes the Institute for Energy and Environmental Research, Skateistan, serving as environmental justice manager for Tewa Women United, and as public education and outreach director at Concerned Citizens for Nuclear Safety. (Courtesy Sadaf Rassoul Cameron.)

Connie Tsosie Gaussoin (1948–)
Tsosie Gaussoin was born in Santa Fe, where she attended area Catholic and public schools, graduating from the Up with People High School in New Rochelle, New York, in 1967. Throughout her career, she has served as a board member for organizations that promote children, culture, art, and Native American relations. Among these organizations are the Santa Fe Opera, Museum of New Mexico, New Mexico State Fair, the Sangre de Cristo Girl Scouts Council, United Way, the 8 Northern Pueblos Artisan's Guild, the SWAI Indian Market, and the IAIA annual gala. For 10 years, she also hosted her own radio show on KVSF, and in 1964, was an Indian princess in the Santa Fe Fiesta. Today, she works as a jeweler and designer. (Courtesy Linda Carfagno.)

Molly Sturges (1966–)
Sturges is the founding artistic director of Littleglobe. Through her work as an artistic director, composer, performer, and activist, she has focused on social and environmental equity and healing through the collaborative arts. She believes deeply in the power of creative exchange to transform personal and collective breakdowns into sources of renewal and vision. Sturges grew up in the Denver/Boulder area and has been based in Santa Fe since 2001. (Courtesy Kate Russell.)

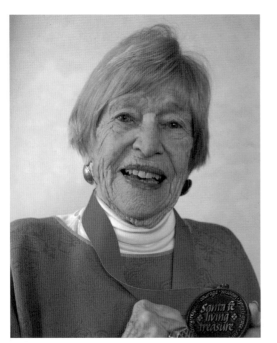

Mary Lou Cook (1918–)
Cook started Santa Fe's Living Treasures program in 1984 as a way to honor the community's elderly population. Today, a board of 17 members carries out her vision, hosting two celebrations annually to recognize senior citizens that have contributed to the vitality of Santa Fe. Cook moved to Santa Fe with her family during the social unrest of the 1960s and began a peace movement in town. Since that time, Cook has been an active community leader. Her most recent project, the MLC World Bracelet, began in 2007. In it, the word kindness printed in 17 languages is distributed locally to bring awareness and foster peace throughout the world. (Courtesy Steve Northup.)

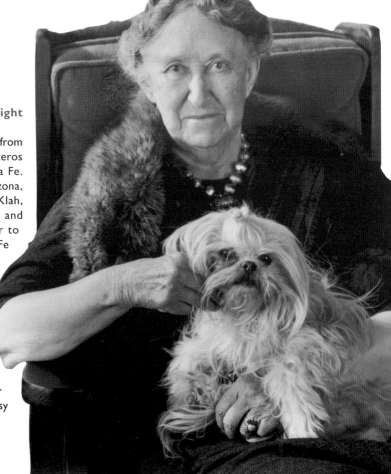

Mary Cabot Wheelwright (1878–1958)
Cabot Wheelwright moved from Boston in 1918 to Los Luceros in Alcalde, north of Santa Fe. During a 1926 visit to Arizona, she befriended Hosteen Klah, a Navajo medicine man, and the two worked together to start a museum in Santa Fe devoted to Navajo culture. Wheelwright provided the financial endowment for the museum, which was designed by William Penhallow Henderson. The Wheelwright Museum of the American Indian is listed in the US National Register of Historic Places. (Courtesy Wheelwright Museum.)

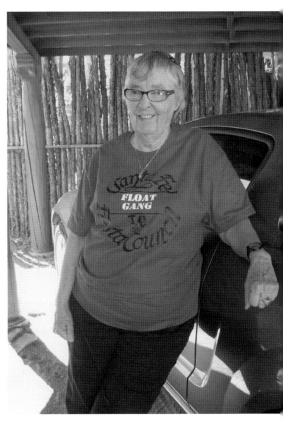

Kimi Ginoza Green (1961–)

Ginoza Green was born in Los Angeles and, since then, has experienced many an adventure, including cleaning fish coming off Morro Bay. She literally crash-landed in Santa Fe in 1981. During a trip to check out medical schools, she had a car accident in town and met Dr. Jay Scherer. The holistic healer left a profound impression on her, and she decided to stay in Santa Fe and study with him. Her professional career includes 24 years of nonprofit and community development leadership and management. She has served as program director for New Cycle Foundation and as director, development and community sustainability for the New Mexico Community Foundation. Green is a consultant for nonprofit development, serves as a board director for numerous social and environmental justice nonprofit organizations, foundations, and funder associations, and is a principal with ReGenStem, LLC. (Courtesy Anne Staveley.)

Louann Jordan (1934–)

When Jordan moved to Santa Fe in 1970, she quickly immersed herself in the city's rich history as a cartographer and community activist. Since 1976, she has been an active member of the Santa Fe Fiesta Council. For 35 years, she worked as a graphics, marketing, and special exhibits specialist for El Rancho de las Golondrinas, Santa Fe's only living museum. In addition to participating in the town's many historical and community organizations, Jordan is an Indy race-car fanatic. For 29 years, she was the president of the Brazilian race-car hero Emerson Fittipaldi's fan club. (Courtesy Ana Pacheco.)

IAIA
INSTITUTE OF AMERICAN INDIAN ARTS

IAIA
Santa Fe's Institute of American Indian Arts, which was founded in 1962, is home to many renowned artists, as well as students that have gone on to educational, legal, and medical professions. In 1986, the IAIA became one of three congressionally chartered colleges with a mandate to preserve and promote all aspects of Native American culture. The other two institutions are Gallaudet University, the nation's first accredited school for the deaf and the hearing impaired, and Howard University, one of the nation's most prominent African American colleges. Hundreds of Native American students, faculty, and alumni from IAIA participate in Santa Fe's annual Indian Market. (Courtesy IAIA.)

Dolores Valdez de Pong (1950–)
During Valdez de Pong's 37 years as a schoolteacher, her focus was the preservation of New Mexico history and culture. In the 1990s, she began composing music and writing plays for children. She discovered that there was very little published material appropriate for use in the classroom. By 2009, she had compiled a work of 99 songs and 14 plays that was published in 2011 by Sierra Blanca Press, entitled, A New Mexican Treasury of Songs and Plays for Children. (Courtesy Dolores Pong de Valdez.)

Caballeros de Vargas
The Caballeros de Vargas is a civic and religious organization, founded in 1956, that fosters the legacy of the conquistador Don Diego de Vargas. The all-male organization plays a key role in the celebration of the Fiesta de Santa Fe, and presides over the annual procession of La Conquistadora. Through their work preserving Hispanic culture and history of Santa Fe, Los Caballeros initiated an endowed scholarship at Santa Fe Community College. They also work to provide financial help to each of the Catholic parishes and to civic and cultural organizations. (Courtesy Juan Manchego.)

Santa Fe Fiesta Council
The Fiesta Council, founded in 1712, is Santa Fe's oldest volunteer organization. It consists of over 100 individuals and more than 20 civic and businesses entities, along with the Native American community. These entities and individuals work together to ensure that the Santa Fe Fiesta, the oldest continuously operated community celebration in the nation, goes off each year without a hitch. (Courtesy Santa Fe Fiesta Council.)

Sisters of Loretto

The Sisters of Loretto was founded in 1812. In 1852, they came to Santa Fe at the behest of Archbishop Lamy and founded an academy for girls the following year. For the next 115 years, Loretto Academy provided quality education for thousands of women in Santa Fe on property just off the plaza where the Loretto Inn and Loretto Chapel are located today. In 1969, the school closed and became a part of St. Michael's High School. In 2012, the Sisters of Loretto celebrated their 200th anniversary in the United States. This is a 1952 photograph of the Sisters of Loretto in Santa Fe. (Courtesy Loretto Mother House, Nerinx, Kentucky.)

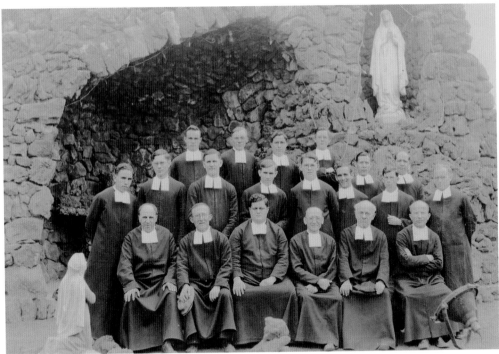

La Salle Christian Brothers

The La Sallian Christian Brothers opened St. Michael's College for boys and young men in Santa Fe in 1859. Their mission was to continue the work of its founder St. John-Baptist de Salle, who opened his first school in 1679 in Reims, France. The college later changed its name to St. Michael's High School and, in 1969, when Loretto Academy for girls closed, it became a coed school. The Christian brothers opened a four-year college in 1947 in Santa Fe, which was formally called St. Michael's College and later changed to the College of Santa Fe. It closed in 2009. Today, St. Michael's High School is one of hundreds of schools in 80 different countries that continues the educational vision of its French founder. This is a 1934 photograph of the Santa Fe Christian Brothers. (Courtesy New Orleans–Santa Fe Christian Brothers District Archives.)

Max Randolph (1931–)
Randolph began working for Berardinelli Family Funeral Service in 1986. For the last 27 years, his responsibilities in caring for more than 3,000 families of the deceased have included arranging rosary services for the family, driving a hearse, and picking up remains at all hours of the night. On June 23, 2006, the main prayer chapel at the funeral home was named in his honor in appreciation for his sensitive and caring manner with the community. Randolph has been a member of Los Caballeros de Vargas for 39 years. He is also a lifetime member of the Fraternal Order of Eagles and a 31-year member of the Elks Lodge. He graduated from Santa Fe High School in 1951. (Courtesy Ana Pacheco.)

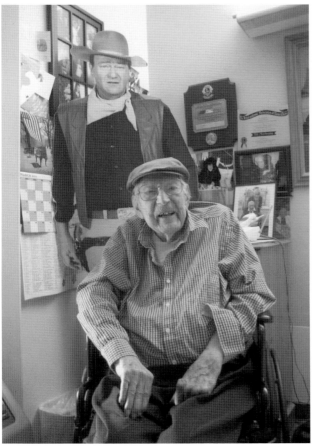

Marvin Langham (1908–2012)
Langham, at 104 years of age, was the oldest active member of the New Mexico chapter of the Lion's Club, a community service volunteer organization. Born in Silver Valley, Texas, he moved to Las Cruces, New Mexico, in 1949 and retired in Santa Fe in 1974. When he figured out that he was not cut out for retirement, he went to work at Bell's department store on San Francisco Street for many years. When he finally retired, he spent time reading about his idol, John Wayne, and kept a life-sized image of Wayne next to his bed as a constant reminder of his long life in the American Southwest. (Courtesy Ana Pacheco.)

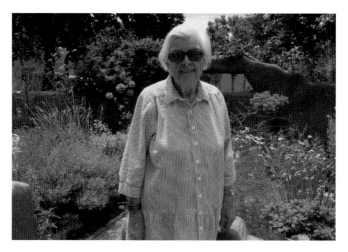

Elspeth Bobbs (1920–)
Bobbs is internationally renowned for her beautiful gardens set in the high mountain desert at her residence, La Querencia, on Santa Fe's east side. Her gardens have been featured by media outlets throughout the world for its hundreds of herbs, plants, flowers, vegetables, and trees grown in the arid desert fed by two wells using drip irrigation. She moved to Santa Fe in 1945 and has devoted her life not only to gardening, but to philanthropy as well. She is a huge supporter of the Democratic Party, KNME (the local PBS affiliate), Planned Parenthood, the School for the Deaf, Santa Fe's Kitchen Angels, and the Farmer's Market, among other causes. (Courtesy Ana Pacheco.)

Marjorie Muth (1915–)
When Muth moved to Santa Fe from Kansas in 1953 after her husband was hired by the Atomic Energy Commission in Los Alamos, she discovered that there were not any programs to help with her firstborn son, Henry L. Muth II, who was mentally retarded. She took it upon herself to create a network for people like her son. Muth became a board member of Santa Maria el Mirador, a center serving the disabled in northern New Mexico. She also devoted time to New Vistas and Northern New Mexico Services for the Disabled. In between her community work and being a housewife and mother, she also taught at Wood Gormley Elementary and was a guidance counselor at De Vargas Middle School. Muth was named a Santa Fe Living Treasure in 2004. Shown is a 1946 photograph of Marjorie Muth and her son Henry L. Muth II. (Courtesy Marjorie Muth.)

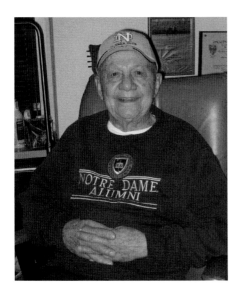

Abdallah Samuel Adelo (1923–)
Adelo was born in the village of Pecos, 17 miles from Santa Fe. For the last 30 years, he has worked with the judicial system as a Spanish interpreter. Adelo graduated in 1940 from St. Michael's High School as the class valedictorian and editor of the school newspaper, the *San Miguel News*. From 1938 through 1940, he was the drum major for the school's band. A graduate of Notre Dame, Adelo, who is fluent in Spanish, Italian, and Arabic, spent the better part of the next three decades traveling the globe while working for Gulf Oil. In 1976, he returned to New Mexico with his wife, Lauretta, and worked in Gulf's coal and uranium business in western New Mexico. Adelo is also a contributing writer for legal and cultural publications in the region and nationally, and continues to teach both law and Spanish. (Courtesy Ana Pacheco.)

Gilbert L. Delgado (1929–)
Delgado moved back to his hometown in 1988 to become the first Hispanic superintendent for the School for the Deaf. To this day, he remains the only Hispanic superintendent of a school for the deaf in the nation. Delgado received his master's degree from Gallaudet University, the nation's first institute of higher learning for the deaf and hearing impaired, where he also was the dean of its graduate school and taught psychology and history. During his tenure, he instituted five masters and one doctoral program. Delgado received his doctorate in educational technology from Catholic University in 1969. He then went on to work for the US Department of Media Services and Film Captioning. While there, he was on the ground floor of creating the first media devices, such as visual captioning for television and movies, for deaf people. During his 40-year career working with the deaf and hearing-impaired, Delgado traveled the globe, advocating for them and spearheading international deafness resource centers at universities in Puerto Rico and Costa Rica. (Courtesy Ana Pacheco.)

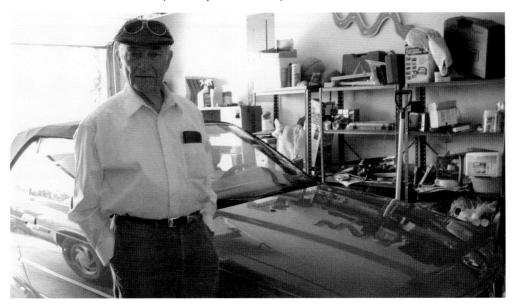

Carl O. Walker (1913–2013)

Walker was born in 1913 in La Plata, New Mexico, 25 miles from Farmington. During the Great Depression, he got a job with Pres. Franklin D. Roosevelt's Civilian Conservation Corps (CCC). In 1936, Walker's company built cabins 16 miles north of Santa Fe at Hyde Memorial State Park that are still in use today. While the CCC was helping to construct the National Park Service office located on Old Pecos Trail, Walker's business acumen caught the attention of that organization, and he was offered a job. For the next 33 years, he worked in locations all over the country for the National Park Service, doing budget and finance work. When it came time to retire, Walker and his wife, Meraldine, came back to Santa Fe, the town that brought them together in 1938. Walker is fifth from left in the 1934 group photograph above. (Left, courtesy Ana Pacheco; above, courtesy Carl O. Walker.)

Louis Zucal (1923–)

As a physician for more than four decades in Santa Fe, Zucal ministered to the needs of the community with their various ailments. For those too sick to travel, he made house calls. Zucal was the officiating doctor at the state's only gas chamber execution in 1960. From 1972 through 1982, he was also the physician for the New Mexico state prison and was on call during the prison riot on February 3, 1980. During the uprising, 33 inmates were killed, one of whom was decapitated, and more than 100 were treated for injuries. It was the second-worst prison riot in the nation's history, after the riot at New York's Attica Prison in 1971. (Courtesy Louis Zucal.)

Angela "Spence" Pacheco (1950–)
In 2008, Pacheco was the first woman to be elected as the first judicial district attorney in the counties of Santa Fe, Los Alamos, and Rio Arriba. She was reelected for a second term in 2012. Pacheco, a 1967 graduate of Loretto Academy, received the nickname "Spence" in high school. Because of her helpful nature, friends and teachers decided that she was "indispensable." During her formative years, Pacheco had leadership roles in both the Girl Scouts and Brownies. In 1980, she was one of the founders of La Nueva Vida, an adolescent treatment program in northern New Mexico. In 1982, she was the president of the VFW Post 2951 Ladies Auxiliary. Angela "Spence" Pacheco is the author's older sister. (Courtesy Angela "Spence" Pacheco.)

Carol Jean Vigil (1946– 2009)
Vigil was the first Native American woman to be elected a US district judge, and was the first Native American elected a state court judge in New Mexico. A member of Tesuque Pueblo, Vigil received her law degree from the University of New Mexico in 1977. She was the first Pueblo Indian woman to be accepted into the New Mexico Board of Law. (Courtesy *Santa Fe New Mexican*.)

Rabbi Leonard A. Helman (1927–)
Helman was Santa Fe's first rabbi when he came to town in 1974. His first post was at Temple Beth Shalom, at the time the city's only Jewish congregation. During that time, he also worked as a lawyer for the New Mexico Public Service Commission. In 2004, he established a scholarship at the New Mexico School for the Deaf. An international competitor in bridge tournaments, he founded the Leonard Helman Bridge Center in 2008. Helman also provides scholarships for children interested in bridge, in the belief that the game will provide them with analytical skills necessary for their future. (Courtesy *Santa Fe New Mexican*.)

Michael A. Olivas (1951–)
Olivas was born at the US Army Hospital in Tokyo during the Korean War to Sabino Olivas III, a native of Santa Fe, and Christine Childers Olivas. He is the William B. Bates Distinguished Chair in Law at the University of Houston Law Center and director of the Institute for Higher Education Law and Governance. Since the start of his association with the university in 1982, Olivas has worked in leadership roles, receiving numerous accolades and awards for his work. He is the author and/or coauthor of 14 books, including *Suing Alma Mater: Higher Education and the Courts*, published by Johns Hopkins University Press in 2012. Olivas is currently working with issues involving higher education and immigration. He has drafted successful immigration legislation that has assisted states, institutions, and legislatures to unravel the ongoing status of immigrants. Olivas and his wife, Dr. Augustina Reyes, spend their summers and semester breaks in Santa Fe, where they maintain a home. In the meantime, Olivas cherishes his New Mexico state resident status, which provides him the right to vote and support local politicians. (Courtesy Michael A. Olivas.)

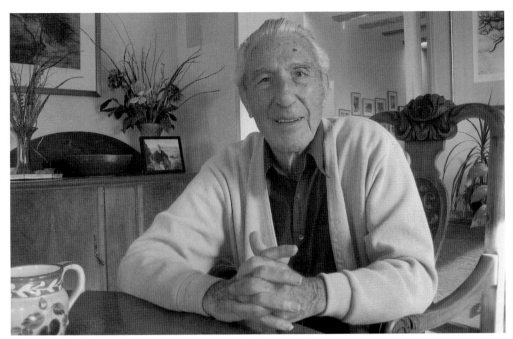

Stewart L. Udall (1920–2010)

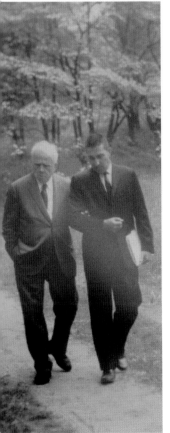

Udall, who was born in St. Johns, Arizona, just 250 miles from Santa Fe, has deep roots in the West. His grandfather, David K. Udall, started the Mormon settlement in St. Johns in 1880. Stewart Udall and his wife, Lee, moved to Santa Fe in 1989 and embraced the community with their unwavering endorsement of Lloyd New and other founders of the Institute of American Indian Arts (IAIA), which celebrated its 50th anniversary in 2012. It was one of the organizations that the Udalls supported in Santa Fe. During his political career in Washington, DC, Udall distinguished himself, first and foremost as an environmentalist. During both the Kennedy and Johnson administrations, Udall served as the secretary of the interior. During that time, Udall wrote several books on the environment. His first book, *The Quiet Crisis*, written in 1963, was a history of environmental conservation in America that made the *New York Times* best-seller list. He also wrote *The Myths of August*, about the effects of radiation in this country, and *The Energy Balloon*, about America's dependence on oil. But Udall's literary accomplishments went further than just informing people on the environment. In 1987, Doubleday published his book *Coronado and Our Spanish Legacy: To The Inland Empire*, a history of the first settlement in the United States, setting the record straight that it was the Spanish, not the British, who were the original explorers, settling in New Mexico in 1598, four years prior to the founding of Plymouth Rock. Although he had no formal training as a writer, Udall also dabbled in poetry. He was a great admirer of the poet Robert Frost, whom he befriended during his years with the Kennedy administration. In the photograph on the left, Udall (right) is seen walking with Frost. A legacy of preserving the environment and writing history is an unusual path for a politician, but Stewart L. Udall took the road less traveled, and, in the words of Robert Frost, "that has made all the difference." (Courtesy Stewart L. Udall and Ana Pacheco.)

INDEX